A MASTERPIECE RECONSTRUCTED

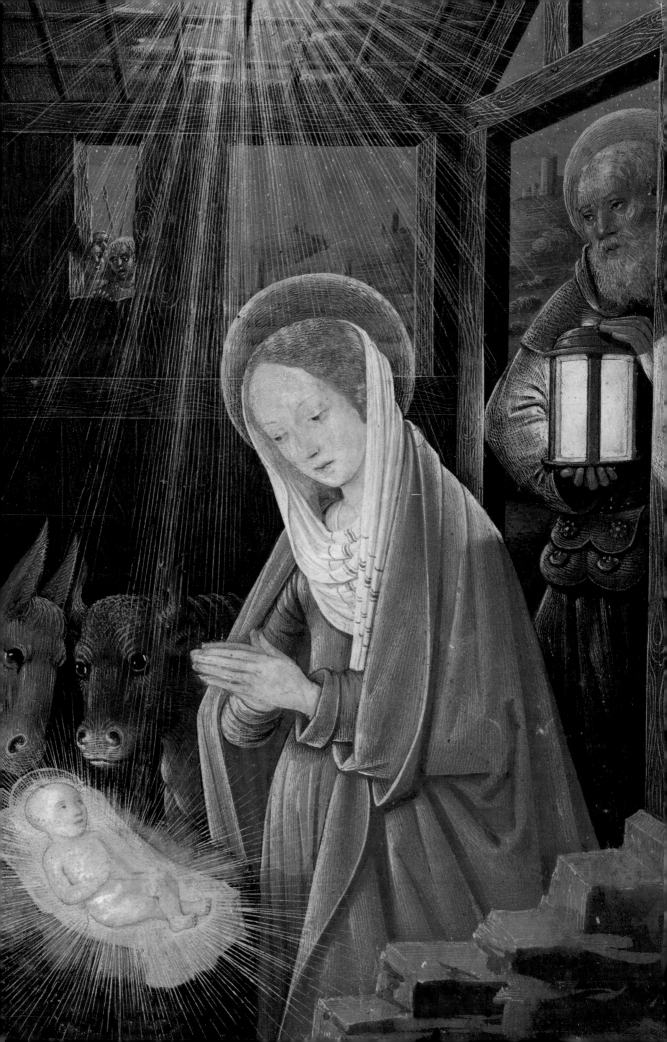

CONTENTS

This publication is issued in conjunction with the exhibition *A Masterpiece Reconstructed: The Hours of Louis XII*, held at the J. Paul Getty Museum, October 18, 2005, to January 8, 2006, and at the Victoria and Albert Museum, February 2 to May 1, 2006.

Getty Publications
1200 Getty Center Drive, Suite 500
Los Angeles, California 90049-1682
www.getty.edu

Published in Europe by
The British Library
96 Euston Road
London NW1 2DB
ISBN 0-7123-4908-1

At Getty Publications
Christopher Hudson, *Publisher*
Mark Greenberg, *Editor in Chief*

Patrick Pardo, *Editor*
Markus Brilling, *Designer*
Amita Molloy, *Production Coordinator*

Typesetting by Diane Franco
Color separations by Professional Graphics, Inc.,
Rockford, Illinois
Printed in Singapore by CS Graphics Pte. Ltd.

In the figure and plate captions for this book, the abbreviation JPGM stands for the J. Paul Getty Museum.

Library of Congress Cataloging-in-Publication Data

A masterpiece reconstructed : the Hours of Louis XII /
Thomas Kren ... [et al.] ; edited by Thomas Kren, with
Mark Evans.
 p. cm.
 Catalog of an exhibition held at the J. Paul Getty
Museum, Oct. 18, 2005–Jan. 8, 2006, and at the
Victoria and Albert Museum, Feb. 2–May 1, 2006.
 Includes bibliographical references and index.
 ISBN-13: 978-0-89236-829-7 (pbk.)
 ISBN-10: 0-89236-829-2 (pbk.)
 1. Hours of Louis XII—Illustrations. 2. Books of
hours—France—Illustrations. 3. Bourdichon, Jean,
1457?–1521? 4. Illumination of books and manuscripts,
French. 5. Illumination of books and manuscripts,
Renaissance—France. 6. Louis XII, King of France,
1462–1515—Books and reading. I. Kren, Thomas, 1950–
II. Evans, Mark L. III. Bourdichon, Jean, 1457?–1521?
 ND3363.L597M36 2005
 745.6'7'0944–dc22
 2005008308

Front cover: Detail of *Louis XII of France Kneeling in Prayer, Accompanied by Saints Michael, Charlemagne, Louis, and Denis* (PL. 1), 1498/99, JPGM
Frontispiece: Detail of *The Nativity* (PL. 11), 1498/99, London, Victoria and Albert Museum
Page vi: Detail of Calendar for *September* (PL. 6), 1498/99, Free Library of Philadelphia
Back cover: Detail of *Bathsheba Bathing* (PL. 18), 1498/99, JPGM

A MASTERPIECE RECONSTRUCTED
THE HOURS of LOUIS XII

Edited by THOMAS KREN *with* MARK EVANS

Essays by JANET BACKHOUSE, THOMAS KREN, NANCY TURNER, *and* MARK EVANS

The J. Paul Getty Museum
and
The British Library
in association with the Victoria and Albert Museum

In memory of MYRA ORTH *and* JANET BACKHOUSE

Foreword

The Hours of Louis XII was one of the greatest French manuscripts of its time, painted by Jean Bourdichon around 1500, during the period when the court of France regained its position as an influential center of art and culture within Europe. This exhibition celebrates the separate purchases by the J. Paul Getty Museum and the Victoria and Albert Museum (V&A) of important miniatures from this masterpiece that, notwithstanding the dismemberment of their host manuscript, have survived the ravages of time with remarkable freshness. By coincidence both our purchases occurred in 2003, the same year that several other miniatures from the book appeared on the market, and not long after the rediscovery of other leaves from it. Most of the components of the Hours of Louis XII exhibited in Los Angeles and London are being reunited for the first time since the book was broken up more than three hundred years ago.

Today the Hours of Louis XII survives principally as a series of sixteen large and imposing miniatures. Fifteen of these have been assembled here, along with a portion of the manuscript's text, for the enjoyment and edification of our visitors. This display offers the opportunity to experience the book and enjoy its illumination largely in its original sequence. Several other manuscripts by Bourdichon from the British Library and the Getty are included to provide some art historical context. We are greatly indebted to the British Library, which owns three miniatures from the book as well as its text block. Accordingly, we would like to thank Lynne Brindley, the Library's Chief Executive, and Scot McKendrick, Head of Medieval and Earlier Manuscripts, for their generous support of this project, the wonderful loans, and the copublication of this volume with the Getty.

We are also most grateful to the other lenders of miniatures from the Hours of Louis XII. These include, at the Free Library of Philadelphia, Elliot Shelkrot, President and Director, and William Lang, Head, Rare Book Department; at the Musée du Louvre, Paris, Henri Loyrette, Director, Carel van Tuyll van Serooskerken, Head, Département des Arts Graphiques, and his colleague Catherine Loisel; at the National Library of Scotland, Edinburgh, Murray Simpson, Manuscripts Collections Manager, and Olive M. Geddes, Senior Curator; at the Bristol City Museums and Art Gallery, Sheena Stoddard, Curator of Fine Art; and, in London, Sam Fogg on behalf of a private collector. Frances Hinchcliffe kindly conserved the Bristol miniature. We acknowledge

additional loans to the Getty Museum and convey heartfelt thanks to David Zeidberg, Director of the Huntington Library, and Mary Robertson, Curator of Manuscripts; as well as Andrea Rich, Chief Executive, the Los Angeles County Museum of Art, Nancy Thomas, Deputy Director for Curatorial Administration, and Mary Levkoff, Curator of European Sculpture.

The miniature of *The Nativity* was purchased by the V&A with the assistance of the National Heritage Memorial Fund, the Art Fund, and the Friends of the V&A. We gratefully acknowledge the generosity of Sam Fogg and Robert McCarthy in supporting the London showing of this exhibition.

Finally we thank Thomas Kren, Curator of Manuscripts at the Getty Museum, and Mark Evans, Senior Curator of Paintings at the V&A, for organizing the exhibition. Along with the late Janet Backhouse, former Curator of Illuminated Manuscripts at the British Library, and Nancy Turner, Associate Conservator of Manuscripts at the Getty Museum, they have made important contributions to this catalogue and to the field of French manuscript illumination.

It is our privilege to introduce this rare and precious book to a wider public.

WILLIAM GRISWOLD MARK JONES
Acting Director *Director*
The J. Paul Getty Museum *The Victoria and Albert Museum*

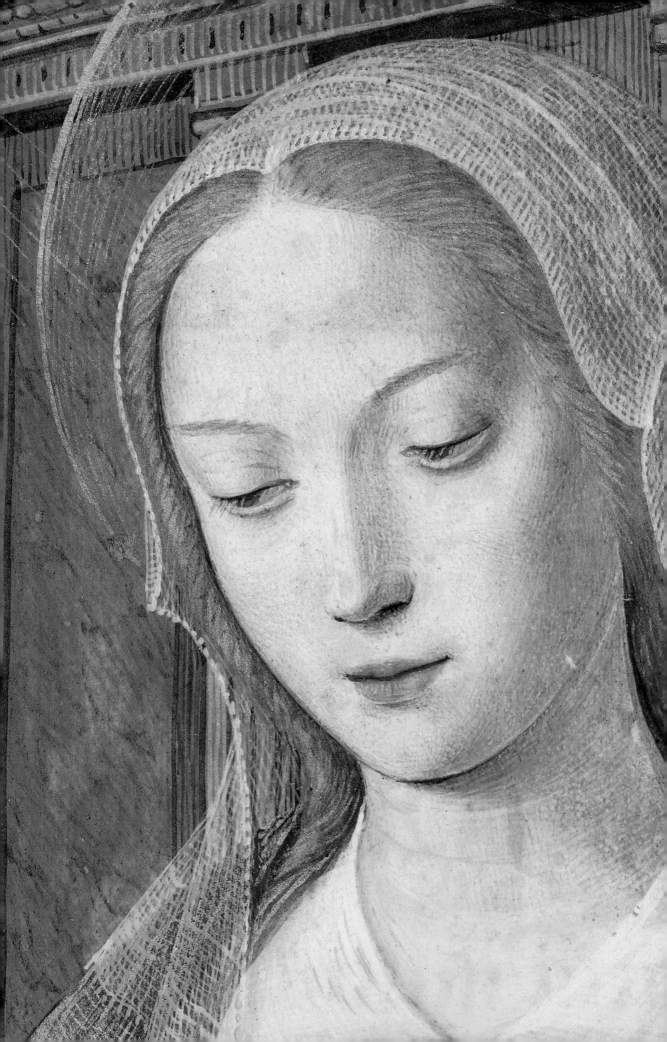

Preface

In 1973 the late Janet Backhouse, the distinguished scholar and Curator of Illuminated Manuscripts at the British Library, published an essay identifying a group of three full-page miniatures and an incomplete and disorganized text manuscript in the British Library, together with another four miniatures, as elements of a major French book of hours. The text had been given to the British Library in 1757, and its three miniatures purchased in 1895, while the additional miniatures had appeared quite recently. This book, probably executed in 1498 and/or 1499, is now known as the Hours of Louis XII. With its large-scale miniatures and innovative three-quarter-length format, this work signaled a new direction in the art of Jean Bourdichon, the painter to four successive French kings. It represents a key monument in manuscript illumination from the last years of one of the most fertile centuries in the history of European art. In her persistent and perceptive manner, Janet had rediscovered a manuscript that had disappeared from history more than three hundred years before.

Two more miniatures from this manuscript surfaced a year after the appearance of Janet's article, and she remained alert for evidence of further leaves. An additional six had been identified by 2001. When the miniature of Louis XII, previously known only in a photograph, appeared on the art market in 2003, she was convinced it came from the same source. Following the Getty's and the V&A's recent acquisition of leaves from the book, we both agreed that the time was ripe to introduce this great treasure to a wider public and to publish all that is known about it in an associated volume. We also felt it would be marvelous to have Janet offer her reflections on the now considerably enlarged group of miniatures. She happily accepted. Yet, even as she completed her research, illness struck. While in and out of the hospital, Janet managed to hammer out a nearly complete draft of her essay on an old, borrowed typewriter, with the active collaboration of her devoted partner of many years, Shelley Jones. The draft arrived in the mail the day before Janet's unexpected and tragic death.

This volume owes an incalculable debt to Janet. We also thank Shelley Jones for enabling Janet's writing. Nancy Turner, Associate Conservator of Manuscripts at the Getty, undertook extensive new research on a number of the leaves from the Hours of Louis XII, as well as some related works by Bourdichon and by Jean Fouquet, to provide a groundbreaking introduction to

Bourdichon's technique as an illuminator. We thank her for her timely and original essay and also wish to acknowledge Peter Kidd, the British Library's Curator of Medieval and Earlier Manuscripts, for providing valuable information and refining Thomas Kren's hypothetical reconstruction of the Hours of Louis XII.

Finally we wish to acknowledge the contributions of those who helped to make possible the exhibition and its handsome catalogue. At the Getty Museum: Quincy Houghton, Assistant Director for Exhibitions, Amber Keller, Senior Exhibitions Coordinator; Sally Hibbard, Chief Registrar, Amy Linker, Assistant Registrar for Exhibitions; and Elizabeth Morrison, Associate Curator of Manuscripts; and at the V&A, Linda Lloyd Jones, Head of Exhibitions, Sue Thompson, Exhibition Organizer; and David Wright, Registrar. Christopher Hudson, the Getty's Publisher, and David Way, Head of Publications at the British Library, joined forces for a copublication that will make the volume widely available in both the United States and the United Kingdom. We express our further gratitude to Getty Publications, in particular Mark Greenberg, Editor in Chief, Karen Schmidt, Production Manager, Patrick Pardo, the ever-patient editor, Markus Brilling, the talented designer, Amita Molloy, production coordinator, and Cecily Gardner, senior staff assistant. The Getty manuscripts were newly photographed for this publication by Christopher Foster, working with Michael J. Smith, Imaging Services Lab, who also labored to ensure the consistency of the images from the Hours of Louis XII. New digital images of the British Library leaves and manuscripts, along with the leaves from the V&A and a London private collection, were made by British Library photographers Laurence Pordes and Chris McGlashon. We thank Scot McKendrick, Peter Kidd, and the photographers for their cooperation in photographing some of the material outside of their own collection in order to help the printers achieve consistency across a significant portion of the illumination in the Hours of Louis XII. The beautiful installation at the Getty is due to Tim McNeil and Michael Lira, supported by Bruce Metro and the preparation staff; and at the V&A to its Design Department.

The catalogue incorporates insights and suggestions generously shared by many experts: Ann Jensen Adams, François Avril, Kurt Barstow, Gregory Clark, Stephen Coppel, Marianne Delafond, Isabelle Delaunay, Kenneth Dunn, Christopher Hughes, Erik Inglis, Martin Kauffmann, Peter Kidd, Sophie

Lee, Scot McKendrick, Marissa Moss, William Noel, Camilla Previte, Stephanie Schrader, Patricia Stirnemann, Rachel Stockdale, William Voelkle, and Roger Wieck. Patricia Stirnemann, Margarita Logutova, and Alexandre Huyghes-Despointes generously helped us obtain some of the illustrations in a timely manner. Georgi Parpulov kindly provided research assistance to Thomas Kren. With advice from Mark Evans, Thomas Kren completed Janet's essay, providing footnotes and a conclusion, while also completing a few sections that were sketched or proposed by the author.

The curators, directors, and trustees of the lending institutions, as well as a public-minded private collector, are all owed our most sincere thanks for allowing their works to be reunited with the parent manuscript on this unique occasion. We thank them and hope that they will be pleased with this permanent record of the event.

Finally we thank Bruce Robertson and Reinhild Weiss for continuing to laugh at our jokes even when they ceased to be funny, and for supporting us in this endeavor.

––––––––––

When Janet initially agreed to contribute to this catalogue, she recalled with pleasure how the three of us had collaborated over twenty years earlier on the catalogue for the exhibition *Renaissance Painting in Manuscripts: Treasures from the British Library*. Our fourth coauthor on that catalogue was Myra Orth, a witty and intrepid colleague, whose life was also cut short in the prime of her scholarly career. Myra's research on sixteenth-century French manuscript illumination opened up new avenues of investigation and fostered the current lively interest in French book arts of the Renaissance. Janet and Myra shared scholarly interests and a close friendship for many years. Janet proposed that this publication be dedicated to Myra. It is now dedicated to the fond memory of them both. We hope the final product is consistent with their exacting standards.

THOMAS KREN
Curator of Manuscripts
The J. Paul Getty Museum

MARK EVANS
Senior Curator of Paintings
The Victoria and Albert Museum

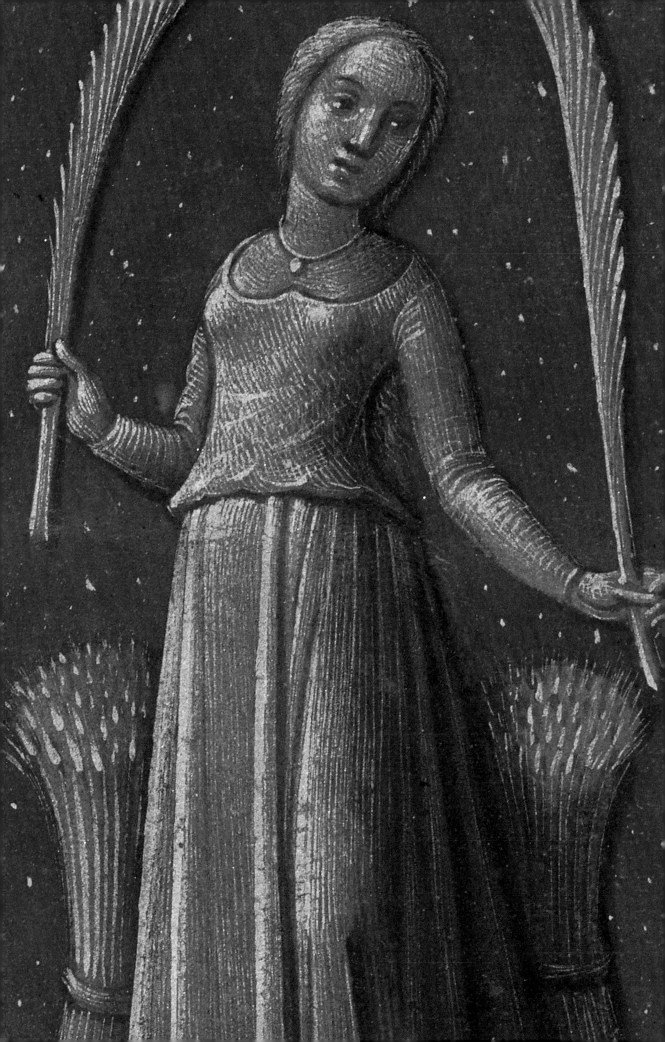

Jean Bourdichon and the Hours of Louis XII

JANET BACKHOUSE

In the year 2003 the striking image of King Louis XII of France (1462–1515) attended by his patron saints Michael, Charlemagne, Louis, and Denis—long lost to sight but familiar to devotees of French Renaissance book painting from a number of old black-and-white reproductions—appeared on the market and was acquired by the J. Paul Getty Museum (PL. 1).[1] Almost simultaneously, miniatures of *The Adoration of the Magi*, *The Presentation in the Temple*, *The Flight into Egypt*, and *Bathsheba Bathing* that are believed to come from the same large-scale book of hours were dispersed from the Bernard H. Breslauer collection in New York, where they had been treasured for some thirty years (PLS. 12–14).[2] A sixth, the ravishing nocturnal *The Nativity*, never previously published or seen by the public, was sold to the Victoria and Albert Museum from a private source in London (PL. 11).[3] The scale and quality of these leaves ensured that all but one quickly found homes in public collections, with *The Presentation in the Temple* and *Bathsheba Bathing* joining the aforementioned Louis XII miniature, titled *Louis XII of France Kneeling in Prayer, Accompanied by Saints Michael, Charlemagne, Louis, and Denis*, at the Getty Museum in Los Angeles. By coincidence, the four Breslauer miniatures had been briefly reunited with three sister leaves from the British Library during the course of the exhibition *Renaissance Painting in Manuscripts* at the Getty Museum, exactly twenty years before (PLS. 9, 15, 19).[4] Eleven full-page miniatures, four calendar pages (PLS. 2–6), and fifty-three text leaves (including PLS. 16, 17) have now been identified as coming from this manuscript, the style and design of which identify it as by Jean Bourdichon of Tours, court painter to four successive kings of France, including Louis XII, during the late fifteenth and early sixteenth centuries.[5] About thirteen additional full-page miniatures remain to be found, together with eight more calendar pages and further leaves of the text.

According to his own testimony, Jean Bourdichon was born at Tours in 1457/58, in the valley of the Loire, which was to remain the center for his activities throughout his long career.[6] The Loire valley was a principal center of the French court and a focus of its patronage, home to the great court book painter Jean Fouquet (ca. 1420–1478/81) and his circle. Bourdichon's career spanned some four decades. He had served Louis XI (1423–1483) and Charles VIII (1470–1498) as court painter before Louis XII and was last heard of

OPPOSITE:
Detail from Plate 4

I

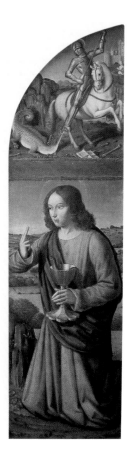

in 1521 (the year he died), contributing to preparations for the legendary meeting between Francis I of France (1494–1547) and Henry VIII of England (1491–1547) at the Field of the Cloth of Gold. Surviving documents refer to payments for a wide variety of decorative works and paraphernalia typical of such a post: banners, standards, furniture, and rolls; designs for coinage, stained glass, jewelry, and gold work; maps, countless portraits, and a number of paintings on panel.[7] Most of this work, often by its very nature ephemeral, has disappeared. A triptych is the single work on panel by his hand to survive (FIG. I.I). Today, however, he is principally known as one of the leading illuminators of his time, responsible for some of its most spectacular manuscripts, largely commissioned by members of the royal family and the court. Ironically, this aspect of his art does not feature prominently in the written records.

In 1880 a document of payment was published, which revealed that in 1508 Jean Bourdichon was assigned the enormous sum of 1,050 *livres tournois* by Anne of Brittany (1477–1514), second wife of Louis XII, for having "richly and sumptuously historiated and illuminated a large book of hours for our use and service where he had invested a great deal of time."[8] A second document, issued ten years later by Francis I, showed that the painter had in fact devoted more than four years to the project, suggesting that the work had begun in 1503 or 1504.[9] Indeed the payment of 1508 was rather more than four times the average annual salary (240 livres) of members of the royal household in 1499.[10] Anne of Brittany was a noted book lover, and her collection included a

FIGURE I.I
Jean Bourdichon, *Virgin and Child Enthroned with Saint John the Baptist and Saint John the Evangelist*, triptych, 1495. Tempera on panel. Central panel: 114 × 74 cm (44⅞ × 29⅛ in.); side panels: 114 × 32 cm (44⅞ × 12⅝ in.) each. Naples, Museo di Capodimonte (on deposit at the Museo Nazionale di San Martino ai Monti)

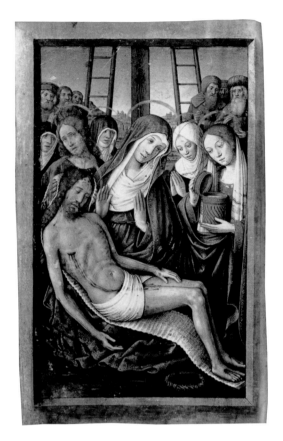
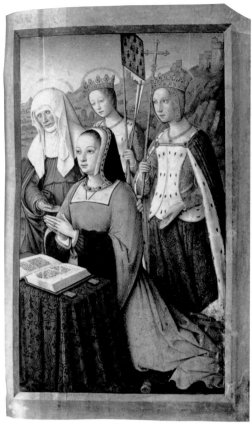

FIGURE 1.2

Jean Bourdichon, *Lamentation*
and *Anne of Brittany Kneeling
in Prayer with Saints Anne,
Ursula, and Helena*. Hours
of Anne of Brittany, ca.
1503–8. Paris, Bibliothèque
nationale de France, Ms. lat.
9474, fols. 2v–3

number of books of hours of various sizes. There was, however, no difficulty in
identifying the manuscript in question as the lavish volume now in the Biblio-
thèque nationale de France (FIGS. 1.2, 1.4, 1.12). Prefaced by a portrait of Anne
supported by saints Anne, Ursula, and Helena, this book has been well known
for several centuries and was reproduced in one of Henri Léon Curmer's
flamboyant chromolithographic facsimiles in 1861.[11] Since 1880 the Hours of
Anne of Brittany has been a touchstone for Bourdichon's style and the basis for
all further attributions.

Bourdichon's career as an illuminator remains to be exhaustively
explored, although attributions of manuscripts to him are abundant.[12] While
he was a major figure in his day, he is conspicuously absent from sixteenth-
century tributes to artists that otherwise include such French masters, also
popular at court, as Jean Perréal and Jean Poyet.[13] His early dependence upon
the art of Fouquet is generally acknowledged, and he inherited the elder
painter's position at court (though not his studio, which seems to have been
continued by Fouquet's sons) after his death sometime between 1478 and
1481. Of particular interest is recent research linking Bourdichon with the
activities of the Parisian scribe Jean Dubreuil, active roughly between 1475 and
1485, whose written work was distributed for illumination among a number of
leading artists of the day, including the Parisian Maître François.[14] The lovely
Katherine Hours is among these books, one of Bourdichon's earliest works
(FIGS. 1.3, 3.19). Instantly identifiable as by Bourdichon, it was commissioned

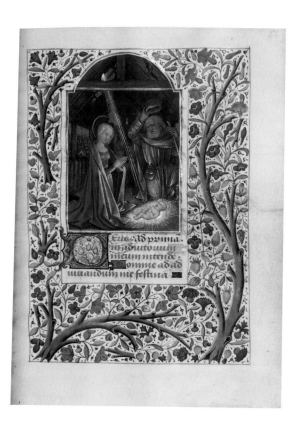

FIGURE 1.3
Jean Bourdichon, *The Nativity*. Katherine Hours, ca. 1480–85. JPGM, Ms. 6, fol. 51

FIGURE 1.4
Jean Bourdichon, *The Nativity* and facing text page. Hours of Anne of Brittany, ca. 1503–8. Paris, Bibliothèque nationale de France, Ms. lat. 9474, fols. 51v–52

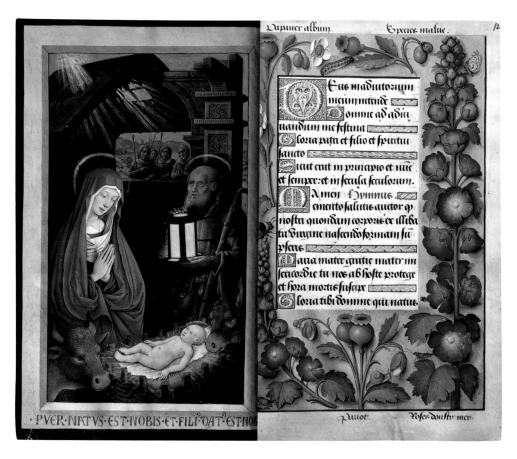

for a couple with the common initials J and K, and its borders incorporate provision for coats of arms, most unfortunately never supplied.[15] Its clear resemblance to the very much later Hours of Anne of Brittany underlines the essential conservatism of Bourdichon's illumination, although his later manuscripts use a very different type of decorated borders from his work of the early 1480s or eschew them altogether (FIGS. 1.2, 1.3, 1.4, 1.12).

Bourdichon's early position at court must have ensured his exposure to the influence of artistic treasures from other European centers. During the 1480s, he was certainly in contact with the court of the young Charles VIII, then still under the tutelage of the king's elder sister, Anne of Beaujeu, Duchess of Bourbon (1461–1522). Other young nobles included the king's child-bride, Margaret of Austria (1480–1530), daughter of Maximilian of Austria (1459–1519) and Mary of Burgundy (1457–1482), and thus heir to the illuminated treasures of the Burgundian ducal library. Also of this group was the daughter of Frederick III of Aragon (1451–1504), Charlotte of Taranto (niece of Louis XI's Savoyard queen), whose likeness is among those known to have been commissioned from Bourdichon.[16] Before his death Charles acquired a major Flemish book of hours, known as "La Flora" (FIGS. 1.5, 1.6), which Bourdichon probably knew, as he seems to have added to the book the king's arms, framed by the type of blocklike gold border also found around the miniatures in the Hours of Louis XII.[17]

FIGURE 1.5
Simon Marmion, *Ascension of Christ*. Book of hours known as "La Flora," before 1489. Naples, Biblioteca Nazionale, Ms. I B 51, fol. 253v

FIGURE 1.6
Flemish illuminator, text page with bar border. Book of hours known as "La Flora," before 1489. Naples, Biblioteca Nazionale, Ms. I B 51, fol. 101v

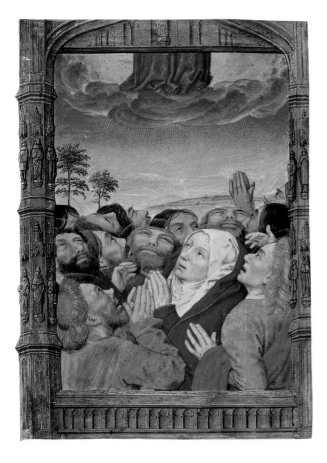

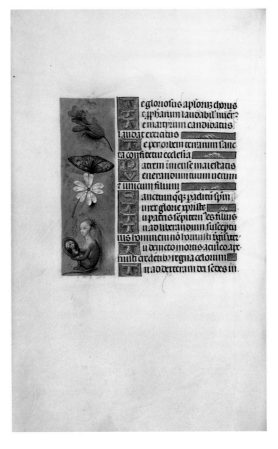

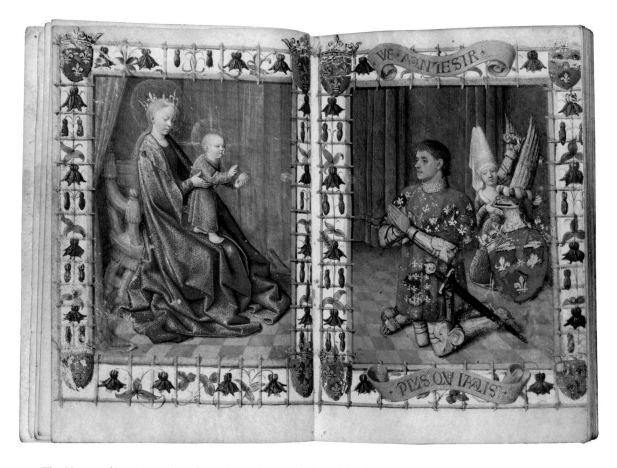

The Hours of Louis XII dates from the midpoint of Bourdichon's career, shortly before 1500. Louis XII succeeded his cousin, Charles VIII, on the throne of France in April 1498 and was crowned at Reims at the end of the following month. Son and heir of the poet-prince Charles of Orleans (1394–1465), Louis was born when his father was almost seventy years of age. After many years as a prisoner of the English, in 1441 Charles married the niece of the Burgundian duke Philip the Good, Mary of Cleves (1426–1487), to whom Louis was born in June 1462. After his father's death, Louis was brought up in the cultured atmosphere of the Orleans court at Blois, where links with the rival Burgundian and French courts remained strong. Louis' godfather and second cousin was Louis XI, who in 1476 married him off to Jeanne of France (1464–1505), the king's crippled younger daughter. During the latter part of the reign of Charles VIII, as it became increasingly likely that Louis would succeed him as king, he was closely allied with Charles in his Italian and imperial ambitions. One of Louis' first acts upon his accession to the throne was to contrive the annulment of his childless marriage to Jeanne so that he could marry Anne of Brittany, the widow of his predecessor, and thus retain Brittany under French control.[18]

It seems likely that the miniature of Louis XII and his patron saints (PL. 1) originally stood at the beginning of his book of hours, in an arrangement parallel to that found in the Hours of Anne of Brittany (FIG. 1.2). Since Anne is shown kneeling in prayer before the Pietà, it is certainly the case that the com-

FIGURE 1.7
Jean Fouquet, *The Virgin and Child Enthroned* and *Simon de Varie Kneeling in Prayer.*
Hours of Simon de Varie, 1455.
JPGM, Ms. 7, fols. IV–2

6

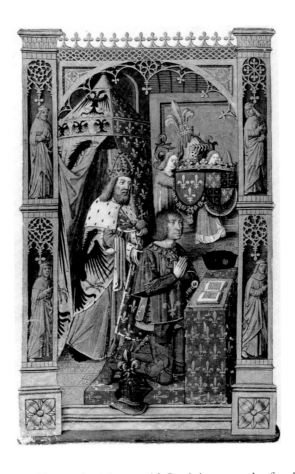

FIGURE I.8
The Master of Jacques de
Besançon, *Charlemagne
Presenting Charles VIII (later
overpainted with the features of
Louis XII)*. Hours of Charles
VIII, before 1498. Madrid,
Biblioteca Nacional, Ms. Vit.
24-1, fol. 3

parably grand miniature with Louis in prayer also faced a devotional image. It
may have been *The Pietà* or, as likely, *The Virgin and Child*. (The latter
appeared, for example, in the frontispiece diptychs of the Hours of Simon de
Varie [FIG. I.7] and the Hours of Etienne Chevalier, both by Bourdichon's
mentor, Fouquet.[19]) The dimensions of the Louis XII miniature (though
trimmed at the top) are compatible with those of the other leaves identified as
coming from the same volume.[20] But its reverse side is blank, lacking the dis-
tinctive border decoration, which characterizes all the other dispersed minia-
tures of the manuscript that have been discovered so far. The diptych with the
Getty Museum's Louis XII was likely added as part of a separate bifolium, as
would be appropriate for a frontispiece. The composition, centered on a kneel-
ing patron formally supported by one or more appropriate saints, is a conven-
tional one, which is found in manuscripts and panel paintings throughout the
fifteenth century. Bourdichon himself had previously been paid for at least one
similar composition depicting Charles VIII, which included both Saint Charle-
magne and Saint Louis, the latter presumably Louis IX of France (1214–
1270).[21] By another hand of the period is the image in the Hours of Charles
VIII in Madrid, subsequently adapted for Louis XII, which has the French
king presented by Saint Charlemagne (FIG. I.8).[22] Nor is this format confined
to royal patrons. Bourdichon had also represented Charles de Martigny,
Bishop of Elne, kneeling in prayer, surrounded by four saints, opposite a sepa-
rate miniature of the Virgin and Child (FIG. I.9).[23]

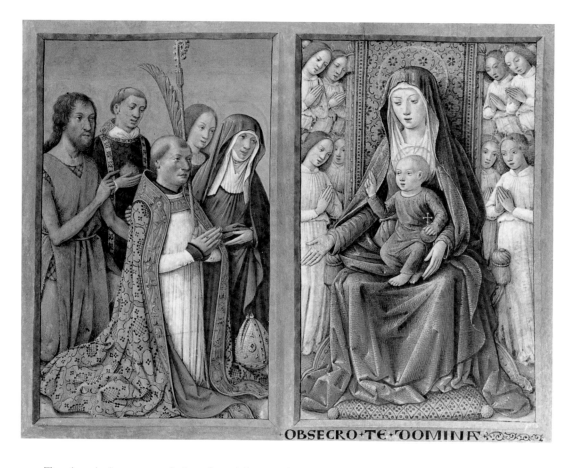

OBSECRO•TE•ꝺOMINA

Two inscriptions appear below the miniature of Louis XII, and the four saints are all identified by name (PL. 1). On the surface of the illusionistic golden frame enclosing the composition is inscribed: "• LOYS • XII • DE • CE • NOM •" and on the burgundy-colored parchment below the frame in a similar but squatter script: "• IL • LEST • FAIT • EN LEAGE • DE • XXXVI • ANS •" Louis had been thirty-five years of age at the time of his accession, his thirty-sixth birthday falling on June 27, 1498. The image in the miniature very closely corresponds to the account of his appearance at his state entry into Paris on July 2, 1498: clad in sumptuous armor covered by a jeweled tabard embellished with his sun emblem, and preceded by his royal helm and crown, surmounted by a "fleur de lys d'or comme empereur."[24] The helmet in Charles VIII's Madrid Hours is comparable (FIG. 1.8). Louis is also wearing the collar of the Order of St. Michel.[25] Bourdichon's Louis XII has every appearance of being based on a formal, official image of the new king. Indeed it is used almost identically, but in reverse (and by a different hand), in the revised introductory miniature in the copy of Ptolemy's *Cosmography* acquired by the king for his library at Blois from Louis of Gruuthuse (1422–1492), the great patron of Flemish Burgundian illuminated manuscripts (FIG. 1.10). The inclusion of the crowned L on the hanging behind the royal figure in the Ptolemy indicates that the book was adapted after Louis came to the throne (unfortunately the date when the Gruuthuse manuscripts were acquired is not known). The reference to Louis' age on the frame of the Getty miniature probably applies to the date of the image

FIGURE 1.9

Jean Bourdichon, *Charles de Martigny, Bishop of Elne, Kneeling in Prayer before the Virgin and Child*, diptych composed of two detached miniatures (shown prior to water damage), ca. 1490. Lisbon, Calouste Gulbenkian Museum, Ms. M 2 A and B

8

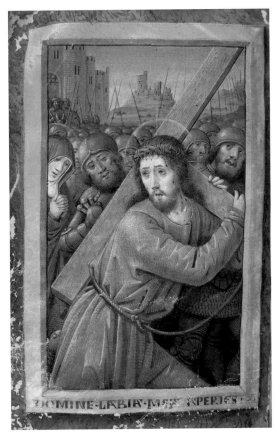

FIGURE 1.10
Louis de Gruuthuse (over-painted with the features of Louis XII) in Prayer before an Altar (detail). In Jacobus Angelus, *Cosmographia Ptolemaei*, last quarter of the fifteenth century. Paris, Bibliothèque nationale de France, Ms. lat. 4804, fol. IV

FIGURE 1.11
Jean Bourdichon, *Christ Carrying the Cross*. Book of hours, Tours, late fifteenth century. London, British Library, Ms. Harley 2877, fol. 44v

rather than the date of the manuscript, though these were probably the same or nearly so.

The burgundy parchment, which is faintly marbled, just outside the painted frame, reflects the desire to give the leaves carrying the miniatures an overall burgundy, and hence royal, character. In this manuscript most of the miniatures have been severely trimmed down at the painted frame so that little of this coloring has survived, but where it does, the coloring is always wine red (e.g., PLS. 9, 13, 18, 19). The burgundy parchment fits with a long-standing tradition in books for royal patrons. However, the hours of Louis' queen, Anne of Brittany, the illusionistic golden frames of the miniatures are set off against a deep shiny black (FIGS. 1.2, 1.4). In a small book of hours from around the same date, which is similarly arranged, but made for an unknown patron, Bourdichon marbled the grounds with a variety of colors, some very delicate (FIG. 1.11). By the end of the century he clearly developed a predilection for colored margins.

Fifty-one complete pages of text from the manuscript, representing eleven portions of its original devotions but now bound up in some disorder, survive among the manuscripts transferred to the newly founded British Museum by George II in 1757 (for example, PLS. 16, 17). Two further leaves, trimmed down to the edges of the text, had previously come to light at the end of the seventeenth century in the collections of script specimens of Samuel Pepys and John Bagford.[26] The leaves in the royal volume, apparently untrimmed, are

spaciously laid out, with wide margins on all sides, giving the original dimensions of the book, 10¾ by 7¼ inches. The vellum is of fine quality, the script elegant, and the initials and line endings delicately executed. On each page a wide panel of crisply painted decoration of flowers and colored acanthus rises to the full height of the text block. Apparently distinctive to this particular manuscript, these border panels display a wide range of realistically painted flowers and fruits, often accompanied by less realistically rendered insects, combined with exuberant and fleshy sprays of formalized foliage in a variety of soft, bright colors. They have also, however, been considered Flemish, due to their similarity to marginal decoration in Ghent-Bruges manuscripts produced from the late 1470s onwards.[27] The Flemish book of hours called "La Flora," which belonged to Charles VIII, had similar bar borders throughout the text, with flowers and insects painted illusionistically on gold grounds (FIG. 1.6). As noted earlier, Bourdichon probably knew this manuscript.[28] The decorated bar borders on the reverse of fifteen of the sixteen leaves with miniatures (e.g., PL. 6) in the Hours of Louis XII provide certain proof that they belong together with the aforementioned text block with its Flemish-style borders (PLS. 16, 17).[29]

In its original state, the text of the Hours of Louis XII opened to the calendar, written out over twelve leaves. Four of these, representing February, June, August and September, have recently come to light (PLS. 2–5).[30] Each month occupies the recto and verso of a single folio, with a saint's feast allocated to every day of the month. The names are decoratively entered alternately in blue and red, with major feasts in gold letters. Headings are elaborated in gold with cadelles and pen flourishes to give a richer effect. The text panels are confined to the upper left-hand portion of the page on each recto and to the upper right-hand portion on each verso, to allow for wide illuminated borders below and to the right of each month on the rectos and to the left on the versos. The borders of the rectos are filled with representations of the appropriate labors of the months and their accompanying zodiac signs. Elaborately illuminated calendar leaves, a tradition popular in the southern Netherlands, are new in Bourdichon's art up to this time. Subsequently, in the Hours of Anne of Brittany, the text panels would be positioned more centrally, allowing for the historiated borders to surround the text completely (FIG. 1.12).

February is represented by the three-quarter-length figure of a well-to-do citizen, warming himself before a blazing fire in a solid, stone-built house with glazed windows (PL. 2). The front of his gown is heightened with gold; his back reflects the red of the flames, demonstrating Bourdichon's skill in representing effects of light. Details of the floor, furniture, and beamed ceiling are lovingly represented. The bench and table behind which the man stands are prepared for a meal. The general impression is one of bourgeois comfort. In the deep blue and gold sky above the roof, the twin fishes of Pisces hover against a background of stars.

In *June* a haymaker, a figure of a distinctly lower class, is seen setting out for work across a flowery meadow (PL. 3). In the distance rise the towers and spires of a small town. The quality of light may be intended to suggest the early

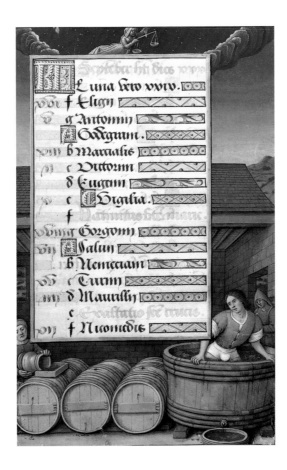

FIGURE 1.12
Jean Bourdichon, *September.*
Hours of Anne of Brittany,
ca. 1503–8. Paris, Bibliothèque
nationale de France, Ms. lat.
9474, fol. 12

morning. Dressed in a simple white tunic and a wide-brimmed straw hat, the man is carrying his scythe and has a whetstone at his belt. A small flask is hanging from his right arm. Trees link the figure to the sign of Cancer in the sky of the marginal panel.

Representing *August,* a second worker is seen inside a barn, winnowing grain after threshing (PL. 4). His clothing suggests that he belongs to a higher class of laborer than the haymaker. Two large sacks of grain are awaiting his attention, and further tools required for his work stand around on the floor beside him. His face, which was crudely repainted well after the book was completed, appears to be turned away from the dust raised by his efforts. As in the *February* picture, the line of the building's roof divides it from the deep blue and gold sky containing the stately figure of Virgo, which is flanked by sheaves of wheat.

The wine harvest provides the inspiration for *September,* with a third workman energetically treading grapes in a large vat alongside a row of hooped barrels, stained with traces of juice (PL. 5). A wooden beam separates the interior of the building from the elegant figure of Libra, within the now-familiar blue and gold sky.

On the verso of each calendar leaf, the entries for the second half of the month are accompanied to the height of the text by a bar border of the aforementioned flower and acanthus decoration (PL. 6). These bar borders, seen on text pages throughout this manuscript (as noted above) and apparently unique

to it, confirm that the calendar belongs to the Hours of Louis XII. Illuminated calendar miniatures for the eight months that are currently missing would undoubtedly have followed the same format as February, June, August, and September.

Of the surviving full-page miniatures, the first to appear in the book was probably the one of Saint Luke writing (PL. 7), which introduced the extract from his Gospel. Selections from the Gospels routinely appear among the preliminary texts in books of hours. The fact that the miniature occupies a complete page indicates that all four Gospel extracts were here originally preceded by full-page miniatures.[31] The saint is shown as a scribe, a pen in his right hand and a penknife in his left hand; his pen case and inkwell lie to his right. His symbol, the ox, occupies the lower right-hand corner of the composition. Unique among the figures in the miniatures from this book, the amiable ox breaks the barrier of the enclosing frame by resting his hoof upon it.

The Betrayal of Christ, introducing the Passion according to Saint John, is likely to have come next among the surviving miniatures (PL. 8). Generally this text does not have a fixed position within a book of hours but is more commonly found toward the front rather than towards the end, where it appears in the Hours of Anne of Brittany. The version seen here was used many times by Bourdichon, with slight variations, and is comparable to the similar miniature in the Hours of Ippolita of Aragon, which has an inscription dated 1498 (FIG. 1.13).[32] It is painted with great delicacy, in a range of subdued tones

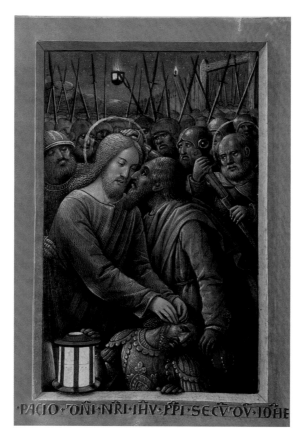

FIGURE 1.13
Jean Bourdichon, *The Betrayal of Christ*. Hours of Ippolita d'Aragon, before 1498(?). Benedictine Abbey of Montserrat, Ms. 66, p. 35

intended to reflect the semidarkness in which the event took place. Once again, direct sources of light have exerted their fascination on the artist, and the rays of torches and lamps play variously upon the figures in the scene.

Six of the nine miniatures from the cycle of the Infancy of Christ have so far come to light. This cycle originally would have introduced the eight individual hours of the Virgin in this manuscript. The sequence began at Matins with a two-page *Annunciation*, of which only the right-hand page survives (PL. 9). It was not uncommon for the Annunciation to be presented as a double opening in French manuscripts of the later fifteenth century (FIG. 1.14). Bourdichon's very simple but sensitive representation of the golden-haired young Virgin Annunciate must surely rank among the finest book paintings of its generation. A gentle light from the tiny Holy Dove casts Mary's shadow on the colored marble behind her. The facing illumination of the Archangel Gabriel remains to be found.

The Visitation, at Lauds, has more pathos (PL. 10). Both Mary and her cousin Elizabeth are visibly pregnant. Elizabeth has a gentle, elderly face and the dark veil of an older woman. Her clothing is discreetly rich, perhaps reflecting a higher social status for her husband, Zacharias, who observes the meeting alongside Joseph from the porch behind the women. The finely detailed, beautifully lit vista demonstrates Bourdichon's skill as a landscape painter.

The Infancy cycle resumes with *The Nativity* at Prime of the Hours of the Virgin, which, along with the exquisite Virgin Annunciate, is artistically

FIGURE 1.14
Jean Colombe, *The Annunciation*. Hours of Anne of France, ca. 1473. New York, Pierpont Morgan Library, M. 677, fols. 42v–43

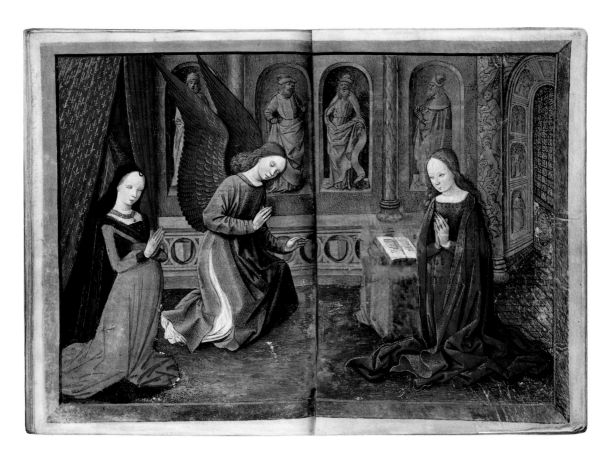

outstanding among the miniatures created for this book (PL. 11). Like other northern European artists, Bourdichon was preoccupied with nocturnal themes and with the play of light within them. Here he gives free rein to his imagination (and demonstrates his technical mastery) by depicting no less than three light sources. The invisible Star of Bethlehem exchanges its golden rays with the radiance emanating from the recumbent Christ child, flooding the Virgin's robes and highlighting the faces of the ox and the ass and of the onlooking shepherds. To the right Joseph holds up a lantern, the artificial white light from which spills down the back of the Virgin's robe. The miniature gives palpable form to the vision of Saint Bridget of Sweden, in which the newly born Christ child "radiated such an ineffable light and splendor" that it rendered superfluous the light from Joseph's candle.[33]

In *The Adoration of the Magi* at Sext, the star is shown, its rays specifically directed towards individual characters in the scene (PL. 12). The Three Kings are arrayed from front to back in the spacious manger in order of seniority. The Child, firmly supported by his mother's protective hands, reaches out to the gold offered by the eldest of the Three Kings.

The Presentation in the Temple at None offers no direct light sources and is set within a cavernous church interior that is notable for its classical, rather than Gothic, character (PL. 13). A crowd spills through a doorway that opens onto a distant townscape. The contrast between this noble setting and the humble environment of the stable is dramatic and moving. Joseph, beside the altar, is charged with the offerings. Both he and the two female attendants concentrate their gaze upon the priest Simeon, who holds the Child. The exchange of glances between Mary and her son perhaps reflects her acceptance of his destiny, "set for the fall and rising again of many in Israel."[34] The "IHS" monogram of the name of Christ runs along the border of the altar cloth.

The last surviving miniature from the Hours cycle, *The Flight into Egypt* at Vespers, presents the Holy Family with an unusual degree of tenderness, as Joseph protectively guides his sturdy donkey through an extensive wilderness (PL. 14). The Child, no longer a baby, is sleeping in a position of complete relaxation, leaning against his mother's shoulder while she supports his feet with her right hand and his body with her left. Along with the aforementioned miniature of Gabriel, still lacking from the Hours of the Virgin are a miniature of *The Annunciation to the Shepherds* at Terce and probably a *Coronation of the Virgin* or an *Assumption of the Virgin* at Compline.

Although it is difficult to know precisely where the Short Hours of the Cross and the Short Hours of the Holy Spirit appeared originally, in French books of hours at this time they often came after the Hours of the Virgin. The miniature introducing the first of these has not been found but probably reflected the image of *Christ Carrying the Cross* in the aforementioned book of hours by Bourdichon from around the same time (FIG. 1.11) or a related subject such as *The Crucifixion*. The resplendent *Pentecost*, which would have illustrated the Short Hours of the Holy Spirit, offers a sea of devout faces, gently lit from above by the golden rays of light from the Holy Dove (PL. 15).

Two further surviving miniatures originally introduced major portions

of the text towards the end of the manuscript. The very naked Bathsheba, with the roguish David in the background, was chosen to open the Penitential Psalms, while *Job on the Dungheap* preceded the Office of the Dead (PLS. 18, 19). Much of the text relating to these two images can be located among the book's surviving text leaves. Other text fragments suggest that at least three further introductory miniatures remain to be found. They would have accompanied the Hours of the Conception of the Virgin (PLS. 16, 17), the Hours of All Saints, and the Hours of the Holy Sacrament. As mentioned before, also lacking are eight calendar miniatures, three Evangelist portraits, *Christ Carrying the Cross* (or *The Crucifixion*), three miniatures from the Hours of the Virgin, and *The Virgin and Child* (or another devotional subject), which originally faced Louis' portrait (PL. 1). In its original state, the Hours of Louis XII thus contained twelve large calendar miniatures and about twenty-four full-page ones, rather less than half the number in the celebrated Hours of Anne of Brittany.[35] What is surprising in such a large and luxurious book of hours is the lack of illustrations to the suffrages of saints, of which six text pages survive. The way they are written, continuously on the page and without a break between them, suggests that this section, which was originally quite extensive, was only illuminated by one or a few miniatures, if at all. In the Hours of Anne of Brittany, the suffrages were copiously decorated with a spectacular series of twenty-seven full-page miniatures. Thus the queen's book of hours was ultimately much more lavish than the king's.

The Hours of Louis XII, even in its incomplete state, represents a milestone in the long career of Jean Bourdichon. By virtue of its large size, coupled with the systematic use of three-quarter-length figural compositions, it inaugurates a new and enduring phase in the artist's career.[36] From now until the end of his life, large dimensions (i.e., books of eleven inches or more in height) dominate his production, including books of hours.[37] The dramatic close-up, showing figures in half-length or three-quarter-length format, became popular in Flemish book art during the 1470s and 1480s.[38] Simon Marmion popularized it during the 1470s, and a French example from the circle of Fouquet dates to the late 1470s.[39] Bourdichon probably was aware of this development, since he also likely had access to a great Flemish cycle of half-length devotional miniatures in Charles VIII's "Flora" hours (FIGS. 1.5, 1.6). That book may have spurred him to explore the wonderfully expressive and intimate qualities of monumental figures in dramatic close-up.[40] Further, in the Hours of Louis XII Bourdichon first employed the Flemish-style illusionistic borders to which the artist would often return. Finally, it is the book that most fully anticipates the best known and loved example of Bourdichon's manuscript production, the opulent Hours of Anne of Brittany.

In some respects Louis' second wife's book of hours represents a culmination of themes introduced in the king's prayer book. It develops and refines a number of the ideas expressed in the latter, in some cases even correcting

them. For example, the layout of the Hours of Louis XII seems somewhat eccentric (see Appendix), with most of the full-page miniatures appearing on the recto of the leaf, or on the right side of an opening, so that only the incipit, or first words, of the pertinent devotion appears inscribed on the frame (FIG. 1.15). One has to turn the page to read the rest. On the left side of the opening, the text page facing the miniature would have contained only a single bar border and represented the concluding lines of the preceding section of devotions.[41] As a result, within an opening with a full-page miniature, an aesthetic imbalance between the large miniature and the facing page, itself modestly decorated and often relatively empty, would have been the result.[42] In the queen's hours the full-page miniatures appear for the most part on the left side, and much more of the associated devotional text is visible on the facing page, striking a happier balance between word and image (FIG. 1.4). Interestingly, this change also reveals how Bourdichon designs a miniature within the context of a book's opening, for in the queen's hours the composition of a given subject is often reversed vis-à-vis the king's hours, as for example in *The Nativity* (compare PL. 11 and FIG. 1.4). Bourdichon seems to have done this in order to redirect the gazes of the main figures in the miniatures toward the center of the book rather than outside it, a choice that shows his sensitivity to the aesthetics and psychological character of visual storytelling as well as to the dynamics of book illustration.

Related to this is the limited use of decorative borders in the Hours of Louis XII where they appear only as modest bar borders on text pages (indeed they show up on every text page). In contrast, conventional Flemish books of hours, the likely inspiration for these decorative borders, featured full illusionistic borders on the text pages opposite the miniature and sometimes even around the miniatures themselves (FIG. 1.16). It may be that Bourdichon felt that a facing full border opposite the full-page miniature made no didactic sense where the facing text page completed, rather than began, a devotion. In the Hours of Anne of Brittany, with the full-page miniatures mostly on the left-hand side of the page, he was free to introduce full decorated borders on the facing pages (in addition to bar borders elsewhere). Thus the full-page miniatures stand face to face with text pages completely surrounded by elaborate floral decoration, very much in the tradition of the commercially highly successful Flemish devotional books (compare, for example, FIGS. 1.4 and 1.16). He further elaborated the manuscript's bar borders by clearly labeling the flora, a feature rarely found in Flemish illuminated books and probably inspired by woodcut illustrations in German printed herbals, which appeared in the 1480s.[43] The result, moreover, is a more aesthetically pleasing two-page opening than the king's hours seems to have had.

Finally, the calendar miniatures of the king's hours are less ambitious and accomplished than those in the queen's hours. In the former they occupy only two sides of the border (see, for example, PL. 2) while in the latter they fill a full, four-sided border (see FIG. 1.12), a format also widely popular in Flemish devotional books by the first decade of the sixteenth century. Still, it is clear that the innovations and sheer ambition of the Hours of Louis XII opened up new

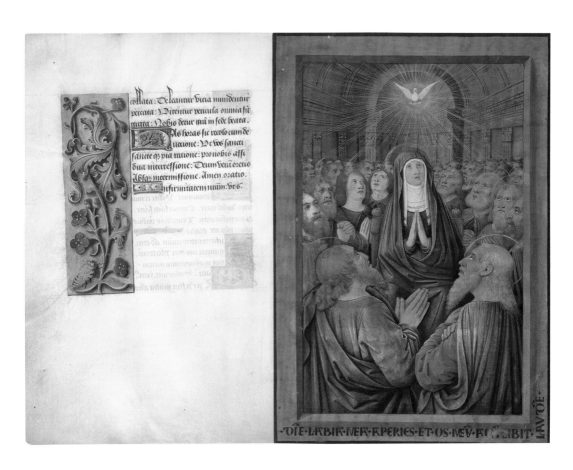

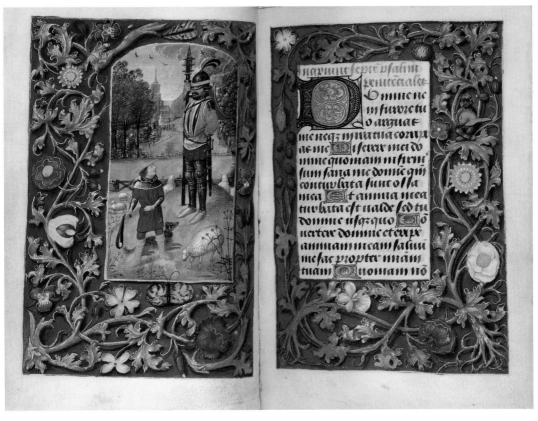

aesthetic avenues for the king's painter and announced significant new directions in his art. The Hours of Louis XII also includes some of the most beautiful and memorable miniatures in Bourdichon's remarkable oeuvre: from the exquisite *Virgin of the Annunciation* to the bold combination of natural, artificial, and spiritual light sources of the nocturnal *Nativity*, from the seductive charms of the temptress Bathsheba to the majesty of the royal portrait. One can only await with keen anticipation the discovery of further miniatures from this great manuscript, which may shed further light upon it and upon this court painter's enduring creativity.

NOTES

1. Since its sale in London in 1920 (Sotheby, Wilkinson, and Hodge, July 14, 1920, lot 67), it has been illustrated in A. de Laborde, *Le roi chevauchant le bouef* (Paris, 1923), pl. vii; Charles Maumené and Louis d'Harcourt, "Iconographie des rois de France," *Archives de l'art français*, 2nd ser., 15 (1927–28), ill. 103, opp. p. 104; R. W. Scheller, "Ensigns of Authority: French Royal Symbolism in the Age of Louis XII," *Simiolus* 13 (1982), p. 93, fig. 14; and Janet Backhouse, "Hours of Henry VII" in Thomas Kren, ed., *Renaissance Painting in Manuscripts: Treasures from the British Library*, exh. cat. (Malibu, 1983), p. 167, fig. 21f.

2. William Voelkle and Roger Wieck, *The Bernard H. Breslauer Collection of Manuscript Illuminations*, exh. cat. (New York, 1992), pp. 76–81, nos. 8–11.

3. Purchased with the assistance of the National Heritage Memorial Fund, the Art Fund, and the Friends of the V&A.

4. Kren 1983. The Breslauer leaves were exhibited in Los Angeles but not published in the exhibition catalogue.

5. Backhouse was the first to ascertain that seven of the full-page miniatures, including potentially the Louis XII miniature, belonged with the surviving text of fifty-three leaves. See her article "Bourdichon's 'Hours of Henry VII,'" *British Museum Quarterly* 37 (Autumn 1973), pp. 95–102. Subsequently Backhouse added to this list *The Adoration of the Magi* (pl. 12) and *The Presentation in the Temple* (pl. 13) (Kren 1983, p. 168, n. 8); Reynaud identified *The Visitation* (pl. 10) and *The Betrayal of Christ* (pl. 8) as belonging to it (François Avril and Nicole Reynaud, *Les Manuscrits à peintures en France, 1440–1520*, exh. cat. [Paris, 1993], p. 295); and Wieck identified the four calendar leaves (pls. 2–5) in James R. Tanis, ed., *Leaves of Gold: Manuscript Illumination from Philadelphia Collections*, exh. cat. (Philadelphia, 2001), pp. 70–74, no. 16.

6. In testimony offered on July 19, 1513, Bourdichon gave his age as fifty-six (David MacGibbon, *Jean Bourdichon: A Court Painter of the Fifteenth Century* [Glasgow, 1933], pp. 52, 150–51).

7. The documentation for much of this is cited by MacGibbon 1933, pp. 35–47.

8. "... *richment et sumptueusement historié et enlumyné unes grans heures pour nostre usaige et service ou il a mys et employé grant temps*..." (MacGibbon 1933, pp. 51, 144). See also A. Steyert, "Jean Bourdichon. Prix et quittance du livre d'heures d'Anne de Bretagne, 14 mars 1508," *Nouvelles archives de l'art français*, 2nd ser., 2 (1880–81), pp. 1–11.

9. MacGibbon 1933, p. 146.

10. Frederic Baumgartner, *Louis XII* (Scranton, Pa., 1994), pp. 59–60.

11. L'Abbé Delaunay, *Le livre d'heures de la Reine Anne de Bretagne* (Paris, [1861]). The manuscript was already a favorite of Louis XIV's at Versailles in the seventeenth century.

12. As studies of the artist's illuminations, the monographs by MacGibbon 1933 and Raymond Limousin (*Jean Bourdichon: Peintre & enlumineur son atelier et son école* [Lyon, 1954]) are largely out-of-date.

13. Reynaud in Avril and Reynaud 1993, p. 293.

14. Thomas Kren, "Seven Books of Hours Illuminated by the Parisian Scribe Jean Dubreuil," in *Reading Texts and Images: Essays on Medieval and Renaissance Art and Patronage in Honour of Margaret Manion* (Exeter, U.K., 2002), pp. 157–200.

15. Reynaud in Avril and Reynaud 1993, pp. 293–94, no. 161.

16. MacGibbon 1933, pp. 49, 141.

17. Thomas Kren in Kren and Scot McKendrick, eds., *Illuminating the Renaissance: The Triumph of Flemish Manuscript Painting in Europe*, exh. cat. (Los Angeles, 2003), pp. 330–34, no. 93.

18. On this event, see the essay by Kren in this volume, p. 57.

19. For the latter, see François Avril, *Jean Fouquet: Peintre et enlumineur du XVe siècle*, exh. cat. (Paris, 2003), pp. 196–97.

20. For example, the dimensions of the Louis XII miniature (pl. 1) are 24.3 × 15.7 cm ($9\frac{9}{16} \times 6\frac{3}{16}$ in.), while those of *The Presentation in the Temple* (pl. 13) and *Bathsheba Bathing* (pl. 18) are 24 × 17 cm ($9\frac{7}{16} \times 6\frac{11}{16}$ in.) and 24.3 × 17 cm ($9\frac{9}{16} \times 6\frac{11}{16}$ in.), respectively. The Louis XII miniature is more trimmed at the top but has a wider margin below the lower frame, which explains the comparable height dimensions given here.

21. In 1490 or 1491 Bourdichon depicted Charles VIII presented by Saints Louis and Charlemagne, but the image is lost. (MacGibbon 1933, pp. 48, 139–40).

22. On the importance of Charlemagne within the self-presentation and propaganda of Charles VIII, see R. W. Scheller, "Imperial Themes in the Art and Literature of the Early French Renaissance: The Period of Charles VIII," *Simiolus* 12 (1981–82), pp. 5–69; and Scheller 1982, pp. 92–93, 107–08.

23. François Avril, "Un nouveau manuscrit de Jean Bourdichon: Les heures de Charles de Martigny, évêque d'Elne" (forthcoming).

24. Bernard Guenée and Françoise Lehoux, *Les entrées royales françaises de 1328 à 1515* (Paris, 1968), p. 128; Scheller 1982, p. 103c; and Baumgartner 1994, pp. 63–65.

25. Cf. the more detailed depiction of the collar by Jean Fouquet in Avril 2003, p. 261.

26. On these specimens, see Mark Evans's essay in this volume, pp. 81–82.

27. George F. Warner and Julius P. Gilson, *Catalogue of Western Manuscripts in the Old Royal and King's Collections* (London, 1921), p. 62.

28. Kren in Kren and McKendrick 2003, p. 333.

29. The justification of the leaves in Royal Ms. 2 D XL is 133/134 × 81/82 mm, while those, for example, in *The Presentation in the Temple* (pl. 13) and *Bathsheba Bathing* (pl. 18) are both 132 × 81 mm.

30. Tanis 2001, pp. 70–74, no. 16.

31. Sometimes in French books of hours, the Gospel extracts are introduced by a single full-page miniature, representing either Saint John the Evangelist or all four evangelists together. It is the survival of an evangelist miniature other than Saint John that suggests the existence of the three others.

32. Dom Anselm M. Albareda, "Els Manuscrits de la biblioteca del Monestir de Montserrat" *Analecta Montserratensia*, vol. 1 (1917), pp. 71–76, cat. 53.

33. Mark Evans, "Bourdichon's *Nativity*," *National Art Collections Fund 2003 Review* (London, 2004), p. 135.

34. Luke 2:34 (King James Version): "And Simeon blessed them, and said unto Mary his mother, Behold, this child is set for the fall and rising again of many in Israel; and for a sign which shall be spoken against."

35. The Hours of Anne of Brittany has forty-nine full-page miniatures plus twelve full historiated calendar borders along with several leaves with illuminated armorials and heraldry. In the tally of twenty-four full-page miniatures proposed here for the Hours of Louis XII, the two miniatures that would have made up the frontispiece diptych and *The Annunciation* are each counted as two rather than one.

36. It bears noting that one other book of hours by Bourdichon does use the three-quarter-length format systematically and also predates the Hours of Louis XII. It is the rather eccentric Hours of Charles VIII (Paris, Bibliothèque nationale de France, Ms. Lat. 1370), where the figures are mostly painted in brown and white monochrome against a painted textile background that the miniature shares with the border, so that the impact of the "dramatic close-up" is diminished (Limousin 1954, pp. 64–65, figs. 94–96).

37. This monumental format seems the antithesis of Bourdichon's most delicate work, such as the Hours of Frederick of Aragon, painted only a few years later, around 1501–04, where the miniatures measure a mere 4¾ × 2¾ inches (Avril and Reynaud 1993, pp. 296–97, no. 163). For some of the large books from the last two decades of the illuminator's career, see also pp. 297–305, nos. 164–68.

38. Sixten Ringbom, *Icon to Narrative: The Rise of the Dramatic Close-up in Fifteenth Century Devotional Painting*, 2nd ed. (Doornspijk, 1984), esp. chapters. 3–6.

39. The Bourbon-Vendôme Hours (Paris, Bibliothèque de l'Arsenal, Ms. 417; Avril 2003, pp. 345–49). Avril believes that Bourdichon may have painted one of the book's lesser half-length illuminations, an initial (fol. 9v; see Avril 2003, p. 346). Ringbom mistakenly attributed the large half-length miniatures in the book to Bourdichon (1984, pp. 209–10).

40. Ringbom 1984, pp. 195–204.

41. As Peter Kidd pointed out in his examination of Royal Ms. 2 D XL, some of the explicit pages of individual devotions are blank on the versos—the text concludes on the rectos—so that a number of the full-page miniatures would have faced pages with only a bar border and ruled lines, but no text at all, and there are also some versos lacking both text and bar borders (though in these instances bar borders still appear on the rectos).

42. The reader should bear in mind that figure 1.15 only simulates a typical opening. It does not represent an actual opening. By an accident of fate, none of the surviving leaves that might qualify as facing pages for any of the surviving full-page miniatures can be identified with certainty as such, so that this example juxtaposes a representative explicit page with a full-page miniature to show how such an opening would have appeared.

43. David Landau and Peter Parshall, *The Renaissance Print* (New Haven and London, 1994), pp. 245–48.

OPPOSITE:
Detail from Plate 13

This section presents the surviving miniatures of the Hours of Louis XII,
along with examples of several text pages, in the order in which they originally appeared in the king's book.
The miniatures were made with tempera colors and gold and silver paint on parchment.

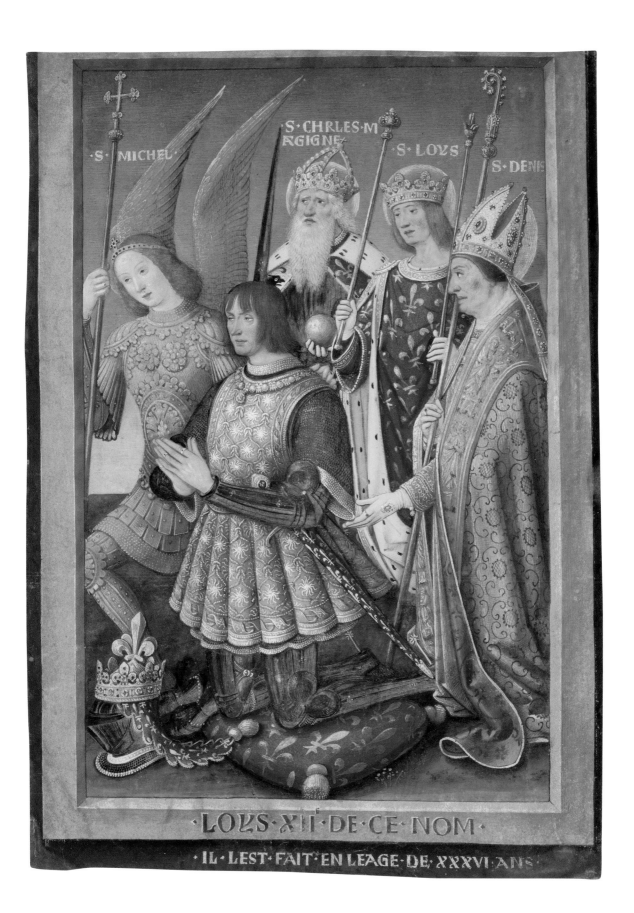

PLATE 1
Louis XII of France Kneeling in Prayer, Accompanied by Saints Michael, Charlemagne, Louis, and Denis
JPGM, Ms. 79a

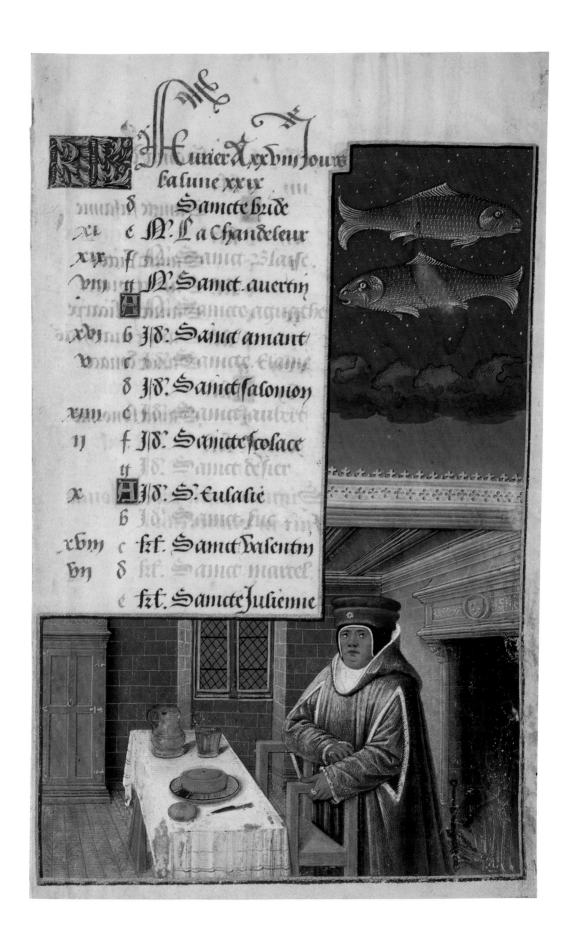

PLATE 2
February
Free Library of Philadelphia, Lewis E. M. 11.19

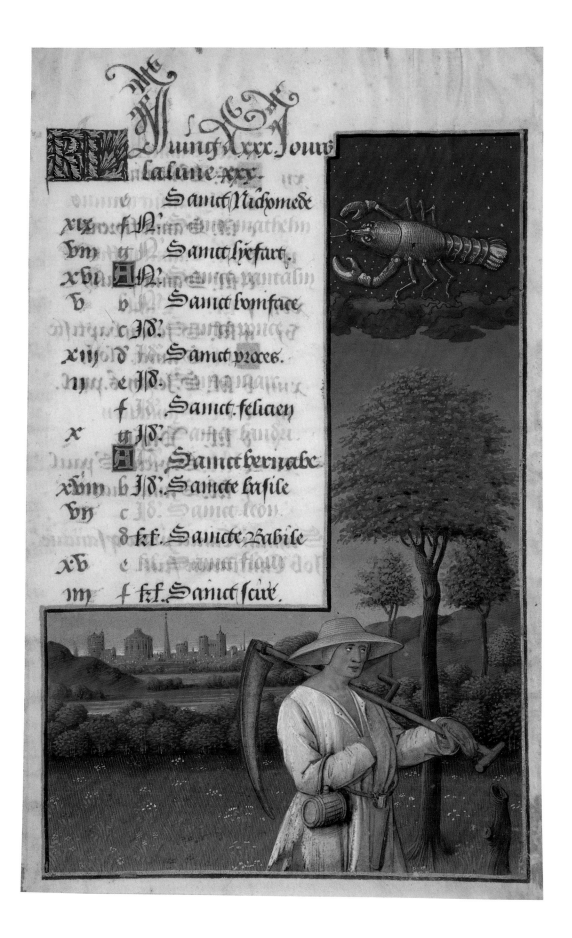

Juing xxx Jours

la lune xxx.

 Sainct Nichomede
xix f N.
vin g N. Sainct lyefart.
xvi N.
v b N. Sainct boniface
 c N.
xiii d N. Sainct proces.
iiii e N.
 f N. Sainct feliacy
x g N.
 Sainct bernabe
xviii b N. Saincte basile
vii c N.
 d k.f. Saincte babile
xv e
iii f k.f. Sainct seur.

PLATE 3
June
Free Library of Philadelphia, Lewis E. M. 11.20

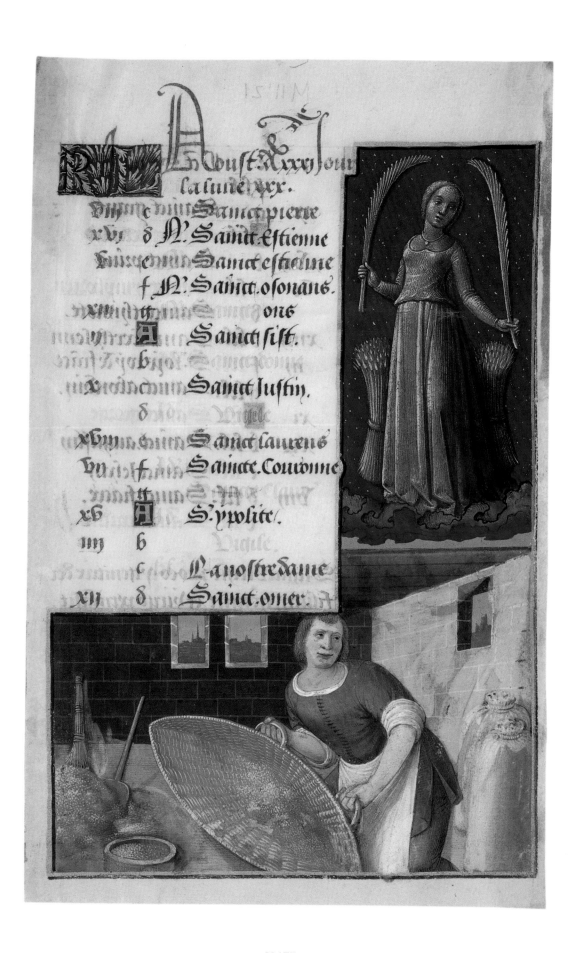

PLATE 4
August
Free Library of Philadelphia, Lewis E. M. 11.21

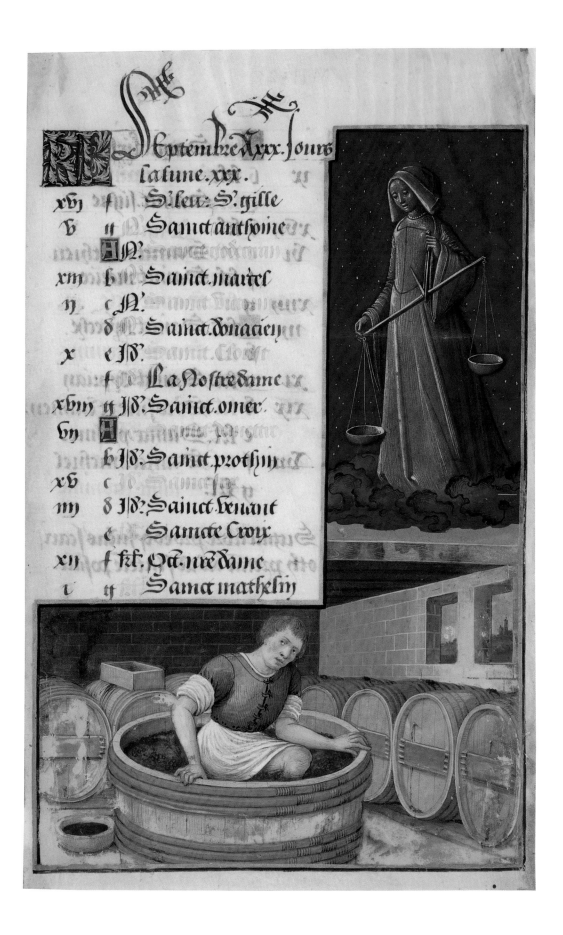

Septembre xxx. Jours
la lune. xxx.

xbj	d viii	Silleu S. gille
b	e ii	Samct anthoine
	f iii N.	
xiij	g iiii	Sainct martel
ij	c N.	
	d	Sainct Donacien
x	e iiii	
	f	La Nostredame
xbiij	g iiii Sainct omer	
bij	a	
	b iiii Sainct protsiu	
xb	c	
iiij	d iiii Sainct benint	
	e	Samcte Croix
xij	f kf. Oct. nredame	
i	g	Samct mathelin

PLATE 5
September
Free Library of Philadelphia, Lewis E. M. 11.22

M 11:22

Saint hessart
ix b kl. Saint ...
Saint. sique
xvii kl.
vi Saint mathieu
f kl. Saint morice
xiiii y kl. Saint ...
iii kl. Saint. hyteche
b kl.
xi c kl. Saint. Cyprian
xix d S. cosme et dam
e kl. Saint. presme
f kl. Saint michiel
y kl.

Signu libre pro eo qz Judas sca
oth premii dei ad statere posuit

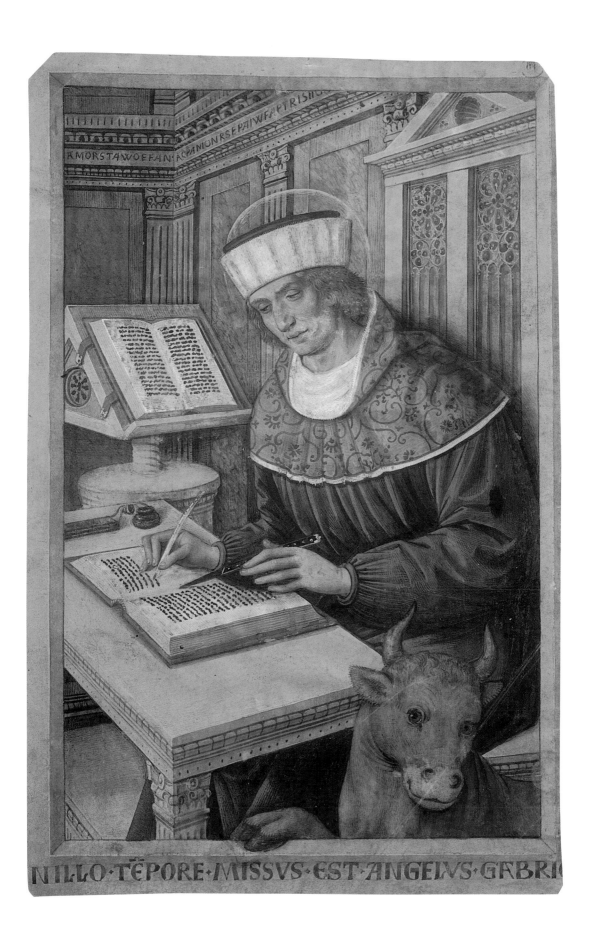

PLATE 7
Saint Luke Writing
Edinburgh, National Library of Scotland, Ms. 8999

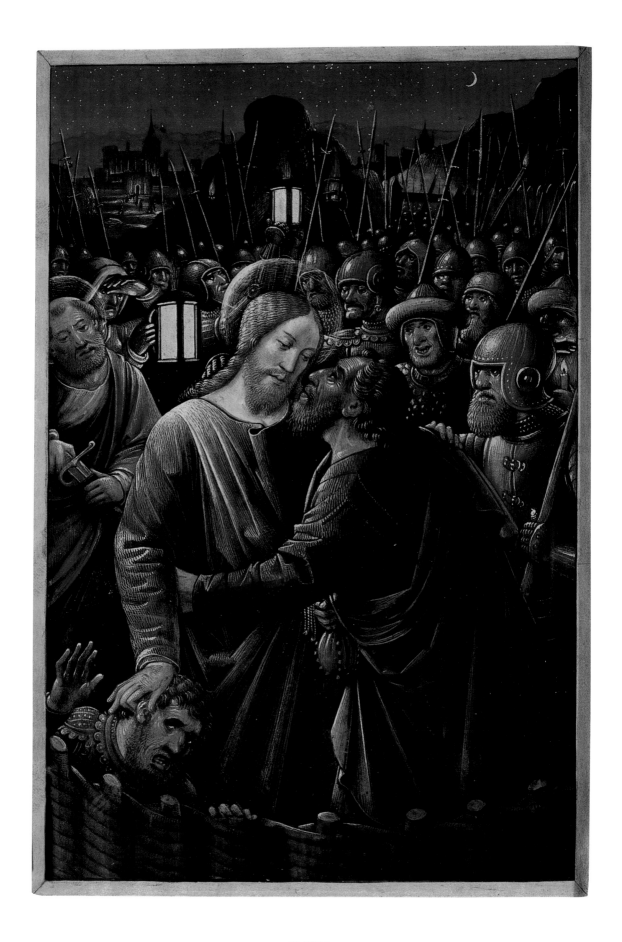

PLATE 8
The Betrayal of Christ
Paris, Musée Marmottan (Wildenstein Collection)

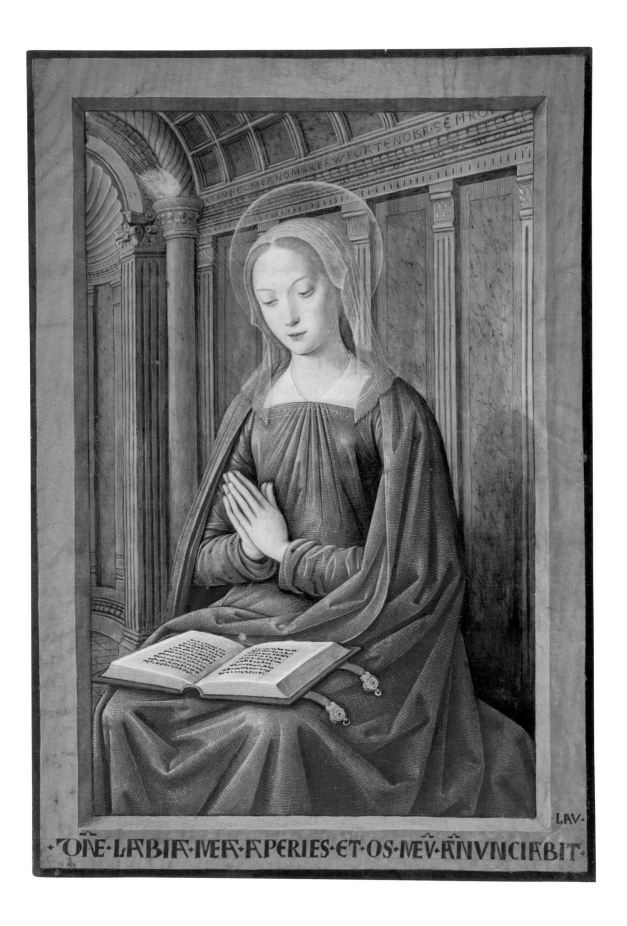

PLATE 9
The Virgin of the Annunciation
London, British Library, Ms. Add. 35254, fol. V

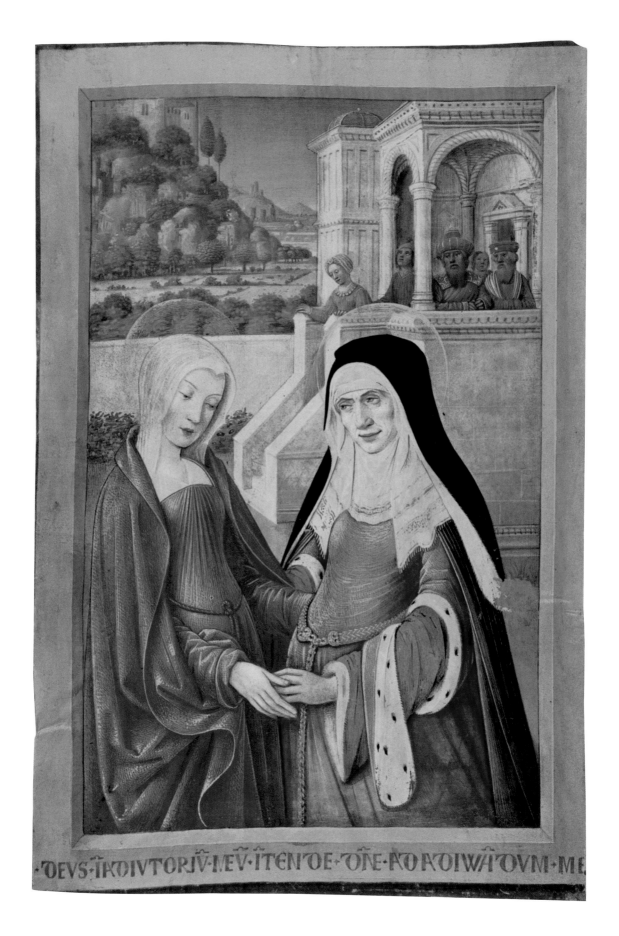

PLATE 10
The Visitation
Bristol City Museums and Art Gallery, No. K 2407

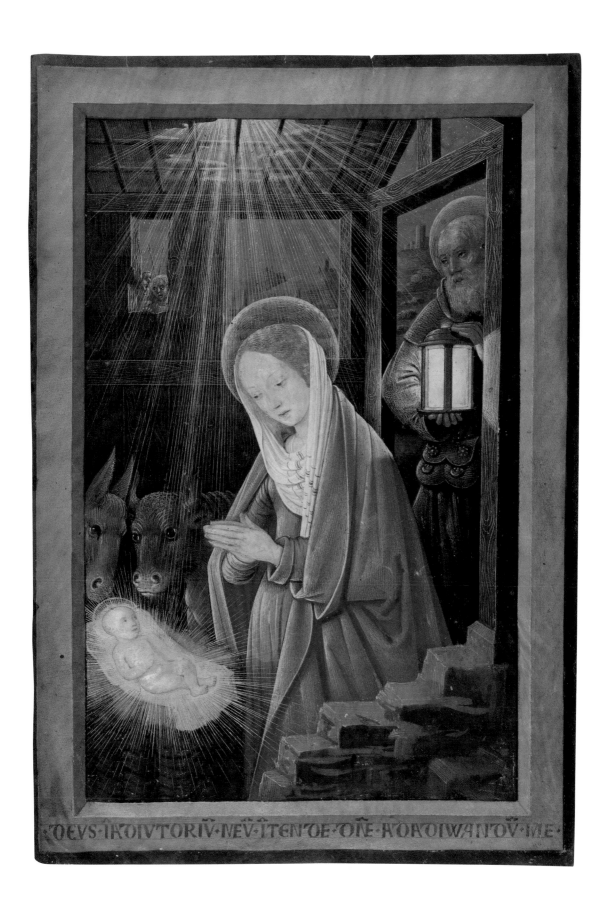

PLATE 11
The Nativity
London, Victoria and Albert Museum, No. E. 949-2003

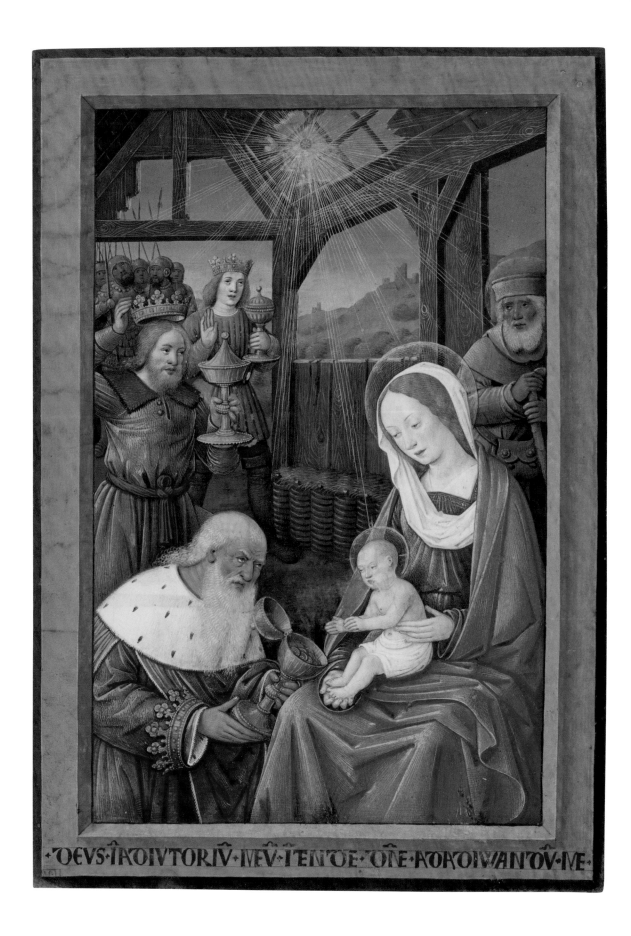

PLATE 12
The Adoration of the Magi
Paris, Musée du Louvre, No. RF 53030

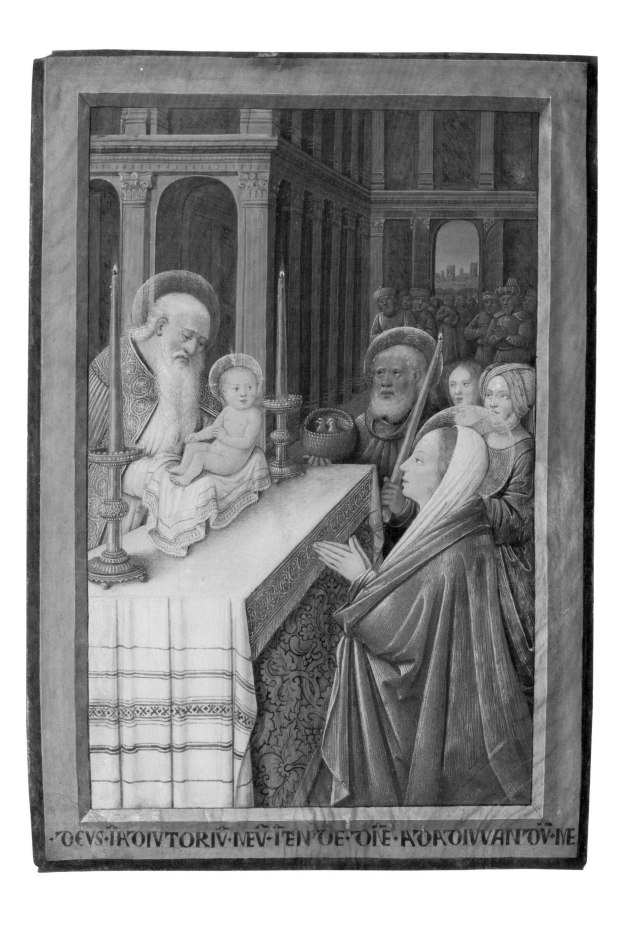

PLATE 13
The Presentation in the Temple
JPGM, Ms. 79b

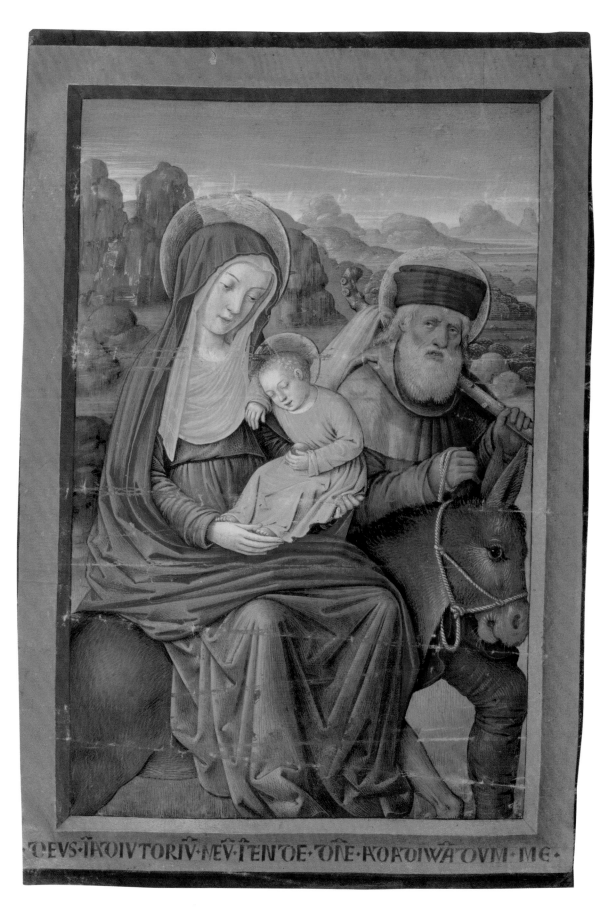

PLATE 14
The Flight into Egypt
London, Private Collection, Loan Courtesy of Sam Fogg

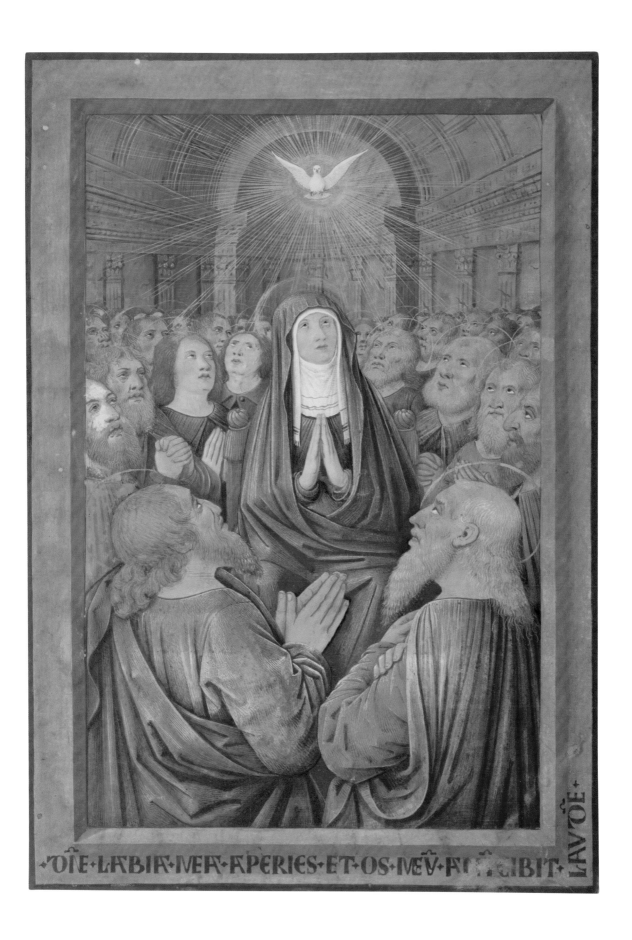

PLATE 15
Pentecost
London, British Library, Ms. Add. 35254, fol. U

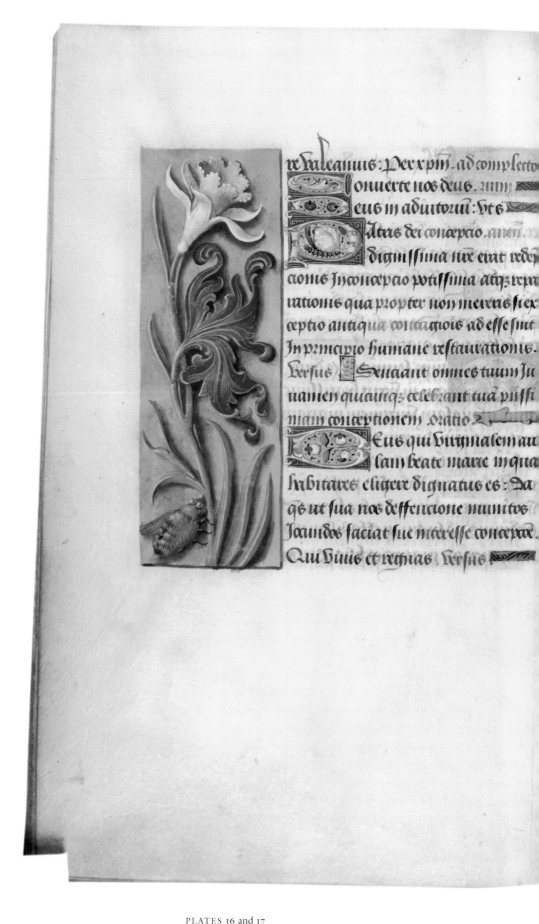

PLATES 16 and 17

Text opening from Hours of the Conception of the Virgin and decorated bar borders

British Library, Royal Ms. 2 D XL, fols. 37v–38

Dum corpus et biscera
que dominū portauerūt
birū finalia libera ihm xpū lactauerūt
beata sint et opera qui bere crediderūt
quod sine labe concepta post et ante re
nanserunt.

Versus. Conceptio tua dei genitrix
birgo: Gaudiū anunciauit bniuerso
mundo Oratio.

Neffabilis clemencie
deus qui corpus et aīas
bate et gloriose birginis marie. bt
bnigeniti filij tui habitaculum effici
mereretur spū sancto cooperante leta
mur eius benigna intercessione a
mortu eterne dampnacionis libere
mur: Per xpm. Ad nonam.

Deus in adiutoriū: bt s.

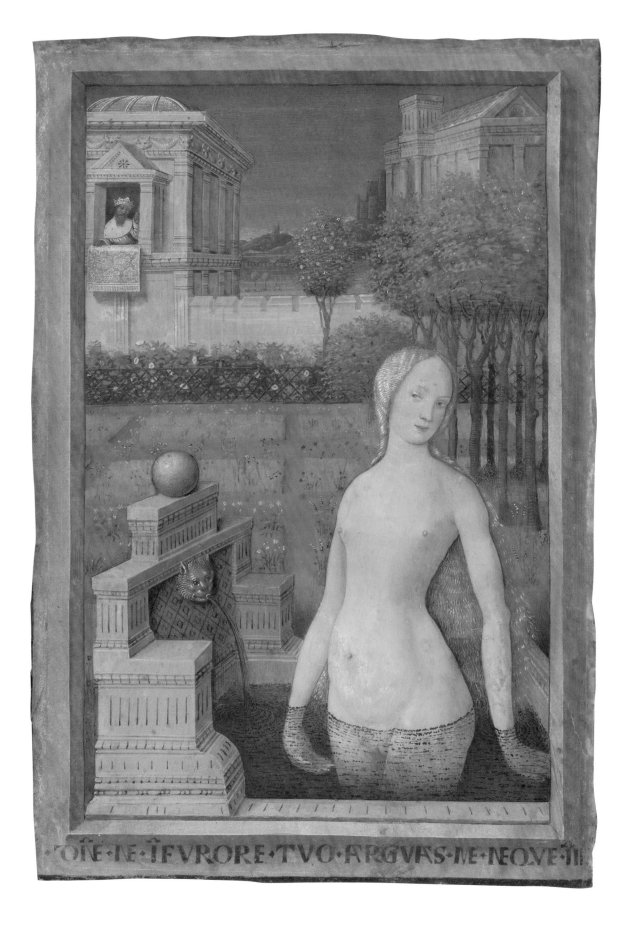

PLATE 18
Bathsheba Bathing
JPGM, Ms. 79

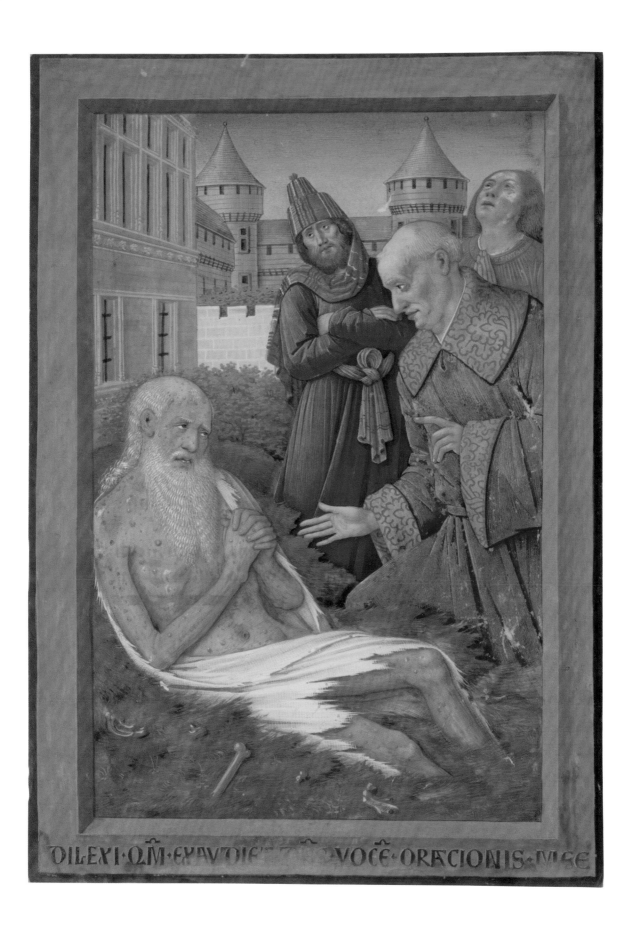

OILEXI·Q̃M·EXAVDIE̅·⁊·VOCẼ·ORACIONIS·MEE

PLATE 19
Job on the Dungheap
London, British Library, Ms. Add. 35254, fol. T

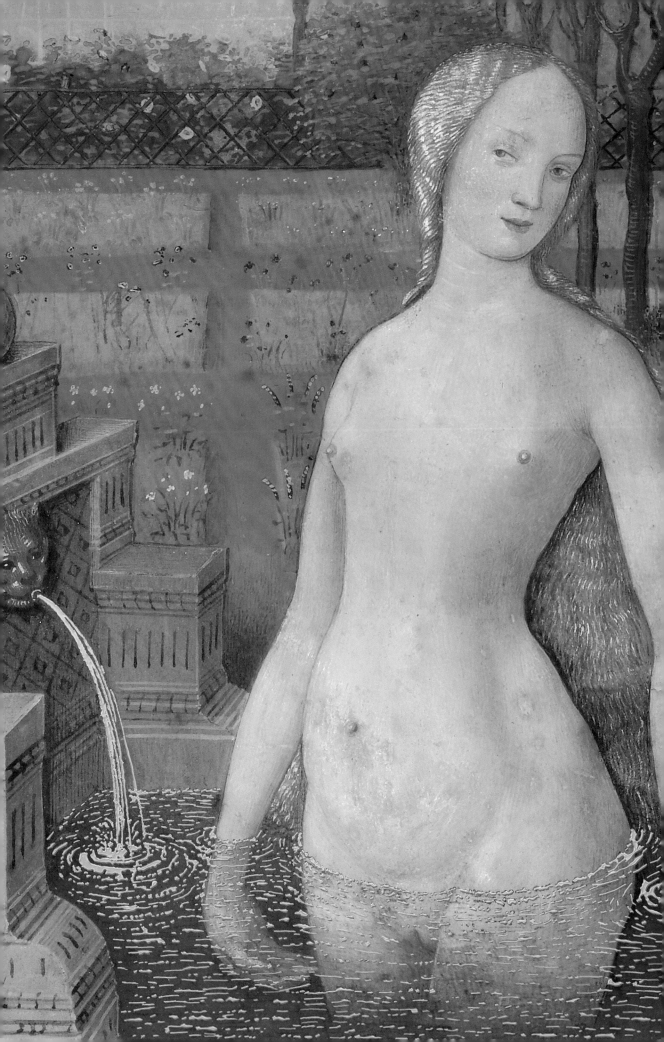

Looking at Louis XII's Bathsheba

THOMAS KREN

In February 1498, King Charles VIII of France was reading a manual of confession that contained a chapter on the sins of the flesh. He drew its teachings to the attention of his cousin, Louis, Duke of Orleans, the future Louis XII, "My brother, this book speaks to you."[1] Louis responded defensively to the king's remark, saying that had he a different wife, this would not be the case.[2] In 1476, King Louis XI, Charles's father, had forced Louis of Orleans, then at the tender age of fourteen, to marry Charles's crippled sister Jeanne of France. The duke soon gained a reputation for avoiding his wife as well as for his enjoyment of other women. Indeed, in November 1498, seven months after he succeeded his cousin on the throne, becoming King Louis XII of France, the papal nuncio commented on the new king's "lascivious" pursuits.[3]

It was probably during the same year, 1498, that Jean Bourdichon, who had been court painter to Charles VIII, began work on the large and very grand book of hours intended for the new king. The inscription on Louis' portrait in the book states that he was thirty-six years old, indicating that the inscription must have been written between his successive birthdays on June 27 in 1498 and 1499 (PL. 1). Thus, presumably, the illumination of the book was underway, and perhaps even completed, within this period. Bourdichon maintained under Louis his position as court painter, the third of four successive kings he served in this capacity.

While the iconography of the surviving miniatures in the Hours of Louis XII is not especially innovative, one miniature stands out: *Bathsheba Bathing* (PL. 18). The well-known moment depicted is related in 2 Samuel, 11:2–27, when King David, from his palace in Jerusalem, spies the beautiful Bathsheba, the wife of the Hittite Uriah, bathing below. David subsequently summoned her to his palace, committed adultery with her, and sent her husband into harm's way, resulting in his death on the battlefield. He then took Bathsheba for his own wife.

Both for its time and to modern eyes, Bourdichon's depiction of Bathsheba bathing within the pages of a pious prayer book is provocative. Using the half-length format to extraordinary effect here, the artist pushes the proportionately large figure of Bathsheba to the front of the image. She is monumental and displayed plainly for the viewer, exquisitely and seductively

43

naked, from the top of her head to just below her pubic area. With its golden highlights, her abundant blond hair, fanning out behind her buttocks, seems to glow on the page. Her pearly white skin is smooth and unblemished. Her small breasts are placed high and wide on her chest, her hips broad; these features shape a voluptuous figure that accords with the highest standards of feminine beauty in fifteenth-century northern Europe. Bathsheba's long arms curve gracefully at the wrist, as if boneless, their movement echoing the ample curves of her body. More tantalizing still, while Bathsheba is immersed in her bath at the hips, her body below that point is still visible through the cool, blue water. Indeed her genitalia are precisely rendered, showing the labia, and originally they must have seemed even more strongly a focus of the miniature than today, because Bourdichon used silver paint, now tarnished, to convey the shimmer of light across the surface of the water (FIG. 2.1 and page 42). The water around Bathsheba's pudenda must have once, like her hair even now, sparkled as well.[4]

In relation to the biblical narrative, this depiction takes liberties. In the miniature, Bathsheba is clearly, happily aware of David at the window of the palace beyond the garden wall, whereas the Old Testament passage states only that she was bathing, not that she noticed him (2 Samuel, 11:2). She coyly cocks her head, displaying her charms for him as well as the viewer, indeed even more brazenly for the latter, who was, initially, Louis himself. Bathsheba is alone, and

FIGURE 2.1
Detail from Plate 18. Digitally restored (using Photoshop CS) by Michael J. Smith, Imaging Services Lab, the J. Paul Getty Museum.

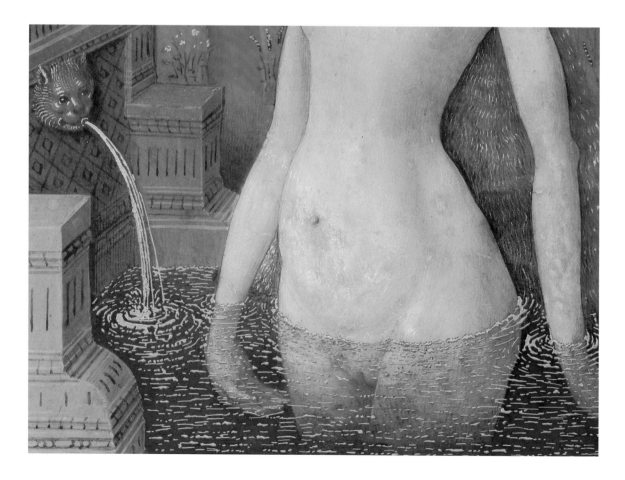

44

with David well in the distance. It is difficult to avoid a conclusion that this Bathsheba was intended to appeal to the book's owner on a visceral level.

The Bathsheba in the Hours of Louis XII deserves our attention because she is such an imposing and original figure and so overtly seductive. This essay will consider the possible meanings of this image for the king. Representations of David and Bathsheba have a long history in medieval art, and the subject had a particular hold on the rulers of France, their families, and members of their courts, in part because David was the preeminent model of Christian kingship. At the same time the fifteenth century witnessed greater sensuality in art and the emergence of the female nude as a theme, especially, but not only, in manuscript illumination, and particularly at the courts of the Valois rulers. The increasingly private and intimate act of reading in the later Middle Ages, which included private devotional books, may have encouraged the production of more explicitly sexual and titillating imagery.[5] In books of hours the subject of Bathsheba bathing became one of the most important vehicles for the female nude, and Bourdichon's Bathsheba will be shown here to represent a dramatic high point in depicting it, a tradition that flourished during the second half of the fifteenth century and into the sixteenth century. At the same time, Bathsheba was interpreted differently throughout the Middle Ages, and it is possible that the figure also carried some levels of association, such as warning against the seductive charms of women even as it seems to celebrate them, that were clear to Louis but are not immediately obvious today. Finally, the following pages will consider how the turbulent sexual politics at the royal court in 1498 may have shaped both the character and reception of Louis' Bathsheba.

DAVID AND BATHSHEBA AT THE COURT OF FRANCE

While not restricted to the ruling households in France, the story of David and Bathsheba enjoyed particular favor within them. Louis XII was not the first French king whose devotional book featured such a prominent image of Bathsheba bathing. This was an important theme in medieval iconography, especially from the thirteenth century. One of the earliest prominent examples of Bathsheba in conjunction with the psalms appears in the Beatus initial, the opening illustration to the collection of 150 psalms, in a psalter made for King Louis IX, known as Saint Louis (FIG. 2.2). The psalter was the predecessor to the book of hours as the preeminent private devotional book, which enjoyed its greatest flowering in the High Gothic era of the thirteenth century. Here the Bathsheba is comparably voluptuous to later images, but more modest. She covers her private area and part of her bosom while averting her gaze from the viewer.

Louis XII's *Bathsheba Bathing* illustrated the Penitential Psalms in his book of hours. A standard feature of books of hours, they represent a selection of seven psalms from the Old Testament's group of 150 psalms. The fictive painted frame of the miniature contains the opening words of the first Penitential Psalm, *Domine ne in furore in tuo arguas me* ("O Lord, rebuke me not in thy indignation"; Psalm 6 in the Old Testament). David's adultery with Bathsheba was one of the transgressions for which he sought forgiveness from

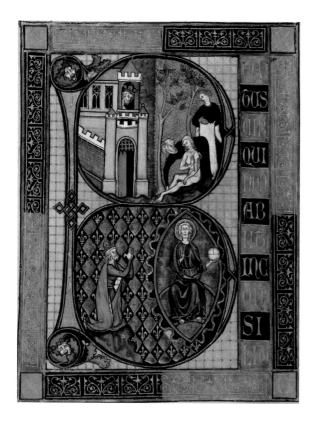

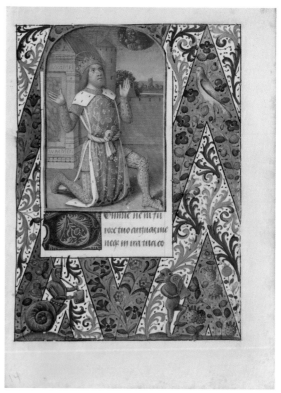

God. While the story itself is told in the second book of Samuel, as noted above, the fourth Penitential Psalm, *Miserere mei Deus* ("Have mercy upon me, O Lord"; Psalm 50 in the Old Testament), is David's response when the prophet Nathan came to him after the king had sinned with Bathsheba.

The most common subject to illustrate the Penitential Psalms, especially in fifteenth-century France, is King David himself, shown kneeling in prayer beseeching the forgiveness of the Lord (FIG. 2.3). *David in Penance* is appropriate to all the Penitential Psalms, not just Psalm 50, since David is also considered to be the author of the Psalms. Despite the popularity of miniatures of Bathsheba bathing from the middle of the century, it remained but one of a range of subjects chosen to illustrate these devotions.

One of its earliest elaborate treatments as a frontispiece to the Penitential Psalms appears in a sumptuous court manuscript, the Hours of John, Duke of Bedford, and Anne of Burgundy, known as the Bedford Hours, illuminated shortly after Bedford became regent of France in 1422 (FIG. 2.4).[6] It avoids the erotic in the story of Bathsheba, omitting the incident of the bath, and leaps ahead to the moment where Bathsheba, summoned by David (but already dressed in a royal gown), is received in the palace. Also shown prominently, to the left of this scene, is David giving to the unsuspecting Uriah the letter that instructs his military leader Joab to send him into the forefront of the hardest fighting, where he will meet his death. The narrative culminates in the background of the image with David's penance before God. It is thus a wholly discreet telling of the tale, focusing upon the events that would cause Bathsheba to become David's queen rather than upon her infidelity. This is particularly

FIGURE 2.2
Beatus Initial. Psalter of Saint Louis, Paris, ca. 1260. Paris, Bibliothèque nationale de France, Ms. 10525, fol. 85v

FIGURE 2.3
Workshop of Bourdichon, *King David in Prayer.* Book of hours, Provence and Tours, 1480s. JPGM, Ms. 48, fol. 98

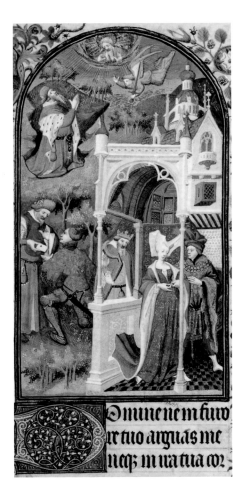

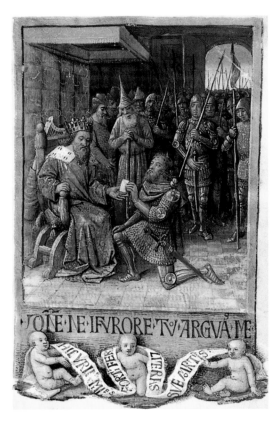

suitable to a book created for a regent, in this case the brother of the recently deceased king and uncle of the heir, Henry VI (1421–1471), at the time of Henry VI's succession. It is also coincident with the regent's marriage to Anne of Burgundy the following year, a union that strengthened England's alliance with Burgundy and may have occasioned the commissioning of this volume. Other aspects of the book's iconography show a self-conscious awareness of the political dynamics of the historical moment.[7] Thus it was possible to tell the story of David and Bathsheba persuasively with no nudity at all. In this miniature, where David is represented looking at Bathsheba, she is fully clothed.

Another book of hours illuminated by the Bedford Master, the painter of the Bedford Hours, and his workshop, features a very close variant of this miniature of David and Bathsheba and is considered by some scholars to have been made for King Charles VII (1403–1461) around the same time.[8] The particular episode showing David giving the letter to Uriah continued to enjoy popularity for generations. A gifted follower of Jean Fouquet painted an imposing version in the Hours of François de Vendôme, ca. 1475–80 (FIG. 2.5).[9] François de Bourbon, Count of Vendôme (1470–1495), was a cousin of King Charles VIII's and the same age. They were close companions from childhood, and François accompanied the king on the Naples campaign in 1494–95, which resulted in François' death. Only a few years after illuminating the

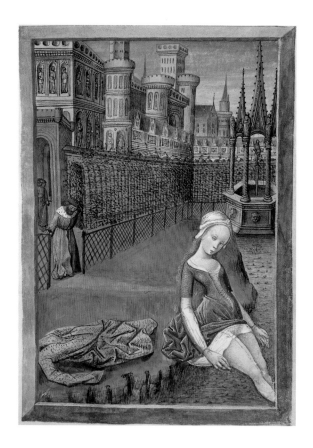

FIGURE 2.6
Jean Colombe, *David and
Bathsheba*. Hours of Anne of
France, ca. 1473. New York,
Pierpont Morgan Library, M.
677, fol. 211

Hours of Louis XII, Bourdichon painted a related composition of the Uriah letter for Frederick III, the final Aragonese king of Naples, who spent his last years in exile at the French royal residence at Plessis.[10]

When the subject of Bathsheba bathing emerges as an important theme in the second half of the fifteenth century, the story is related in a variety of ways. It appears not only in books for men in the royal family and for officials close to the king but also in books for women of the royal household. A book of hours, made for Anne of France, the future Anne of Beaujeu, Louis XI's daughter and regent during her brother Charles's minority, features at the Penitential Psalms an entire cycle of seven miniatures from the story of David and Bathsheba. Probably made for her around 1473, when she had just reached puberty, the book opens with the story of Bathsheba at her bath (FIG. 2.6). Bathsheba is fully dressed, but the hem of her skirt is drawn up to reveal her legs, with only her feet in the water. Her discreet, sidelong glance suggests she is aware of David's approach and of her own physical charms. He is not shown, as is usual, catching a glimpse of her from an upper floor of his palace, but at the gate to her garden, hurrying to see her. This is a striking departure from the biblical narrative, which indicates rather, as noted above, that he had sent for her. Yet the depiction of Bathsheba's flirtatiousness, however discreetly, shows that it was an issue for women as well as for men. In the second miniature, when they are together in the palace, she kneels humbly (and fully clothed) before him while he firmly seizes her wrist.[11] No less than three miniatures in this series deal with Uriah and his terrible fate, underscoring his heroism and the impor-

48

tance of his example for the court. The sixth miniature deals with the prophet Nathan admonishing David, and the seventh with David's penitence. Thus the cycle decidedly favors the chivalric—and, arguably, the dynastic—over the erotic in the narrative of David and Bathsheba. The miniatures were painted by Jean Colombe, a favorite illuminator of Anne's mother, Queen Charlotte of Savoy (1443–1483), who possibly commissioned the book for her daughter.

In summary, the story of David and Bathsheba was long popular at the court of France, among both members of the ruling household and prominent courtiers, in part for the dynastic implications of the story. Prior to Louis XII's provocative Bathsheba, it would appear, the story was told or evoked in a variety of ways and through a range of incidents, some of which, such as David and Uriah, omitted the representation of Bathsheba altogether. Others represented Bathsheba prominently but fully clothed, gave her a more modest character, or showed her as flirtatious but not brazen.

ASSOCIATIONS OF THE SUBJECT OF BATHSHEBA BATHING

During the High Middle Ages, the practice was to imbue the story of Bathsheba bathing with typological significance, with Bathsheba, who purifies herself in her bath, representing Ecclesia, and David as Christ.[12] This is the case, for example, in the aforementioned Saint Louis Psalter (FIG. 2.2): through imagery the Old Testament is unified with the New. Within this context, in the Saint Louis Psalter the treatment of the naked but modest Bathsheba in the act of bathing gives the story a profound spiritual significance.[13] Thus Bathsheba was an anti-type of Ecclesia, as was Eve, and since Bathsheba and Eve were the only two biblical women commonly represented nude in the Middle Ages, they also came to be linked with each other. Like Bathsheba, Eve was pure before she succumbed to temptation,[14] and the association of nudity with Eve's sin reinforced their connection.

During the fourteenth and fifteenth centuries, Bathsheba became a negative stereotype, yet different interpretations apparently coexisted. Bathsheba was such a significant figure in the medieval imagination and at court that she bore the weight of multiple readings, just as Eve did. Louis XII, while still duke of Orleans, acquired a remarkable book of hours, probably made around 1490, which features a comparably naked Bathsheba in the Penitential Psalms.[15] In this miniature she is full length, and her pubic area is fully exposed, not even submerged in water (FIG. 2.7).

More striking is the fact that the Hours of the Virgin of this extensively illustrated book of hours features a cycle of miniatures from the Creation of Eve to the story of Noah. Eve appears in five of the miniatures, and as a physical type she strongly recalls the Bathsheba figure in the same book. In two separate miniatures (fols. 12v and 13v), both representing *The Temptation of Eve*, she is shown full length in the matter-of-fact pose of Bathsheba later in the book (FIG. 2.8). While the picture cycle does not set up an overt comparison between the two, the interchangeability of the naked female types suggests that an awareness of the implicit equation of Bathsheba with Eve continued into the fifteenth century. Indeed the garden with the fountain, a standard fea-

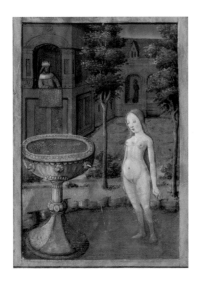
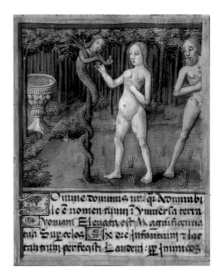

ture of the iconography of both subjects, underscores the visual connection between the Temptation of Eve and the Bathsheba bathing miniatures. In both miniatures of *The Temptation of Eve* (FIG. 2.8), even as Eve's pubic area is exposed, Adam's is omitted either by his pose or by the cropping of the composition. In both, Adam seems to be departing the scene just as Eve takes the fruit from the serpent, so that the body of Eve, alone with Satan, seems more explicitly sinful. Eve's own role as temptress assumes such weight during the Renaissance that in German art, only a decade after Louis XII's *Bathsheba Bathing* (PL. 18), she seems to beckon the viewer directly.[16] Thus, Bourdichon and Louis XII probably had some consciousness of the association of Bathsheba with Eve on several levels, including as a temptress.

This conception of Bathsheba as seductress already is evident in literature from the thirteenth century. In the writings of Brunetto Latini (1220–1294), David is identified as one of the illustrious men who succumbs to folly and misdeeds through feminine wiles: "David showed bad judgment [with a woman] ... there is nothing that women will not reduce to foolishness."[17] Here the woman to whom Latini refers is clearly Bathsheba. In the late fourteenth century, in a popular manual advising his daughters, the Chevalier Geoffroy de la Tour Landry condemned what he perceived as Bathsheba's coquettishness, which led David to acts of adultery and murder. Interestingly for Bourdichon's conception of Bathsheba, de la Tour Landry specifically cites Bathsheba's "very beautiful and blonde hair" as part of her allure. His remarks appear in a section of the text on combing one's hair in front of others:

> She washed and combed her hair [standing] before a window where the king could see her clearly; she had very beautiful and blonde hair. And as a result the king was tempted by this and sent for her ... And so King David sinned doubly by lust and by murder ... And all his sinfulness came from her combing her beautiful hair and her pride in it. Every woman should cover herself, and should not take pride in herself, nor display herself so as to please the world with her beautiful hair, nor her neck, nor her bosom, nor anything that should be kept covered.[18]

FIGURE 2.7
Bathsheba at Her Bath (detail).
Hours of Louis of Orleans,
ca. 1490–95. St. Petersburg,
National Library of Russia,
Ms. Lat. O. v. I.N. 126, fol. 58

FIGURE 2.8
The Temptation of Eve (detail).
Hours of Louis of Orleans,
ca. 1490–95. St. Petersburg,
National Library of Russia,
Ms. Lat. O. v. I.N. 126, fol.
12v

wie Berfabe Vriels des Ritters hufzfrou

FIGURE 2.9
Bathsheba Bathing. In Geoffroy
de la Tour Landry, *Der Ritter
Vom Turn von Den Exempeln
Der Gotsforcht von Erbekeit*
(Basel, 1493). From a modern
facsimile (unpaginated).

This text remained popular into the late fifteenth and early sixteenth centuries
in northern Europe. Copies of it appeared in such Valois libraries as those of
Charlotte of Savoy, consort of Louis XI; Charles the Bold, Duke of Burgundy
(1443–1477); and Louis XII's successor, Francis I.[19] An illustrated printed edi-
tion in German, published in Basel in 1493, includes an illustration of a cheer-
fully bare-breasted Bathsheba (FIG. 2.9).[20] By the fifteenth century, perhaps
inevitably and especially within the intimate context of the book, the image of
Bathsheba as seductress opened up possibilities for illustrating fetching and
unabashed young women in the nude.

THE SENSUAL FEMALE NUDE AND VALOIS PATRONAGE

While we have seen that the naked, albeit relatively modest, Bathsheba occu-
pied a prominent place in the Saint Louis Psalter, Bourdichon's nude, siren-
like Bathsheba belongs to a tradition of depictions of overtly sensual female
nudes that was still young in early-fifteenth-century French illumination.[21]
Tastes and preferences at the Valois courts helped to popularize them.[22] Some
of these depictions illustrate literature, such as the writings of Giovanni
Boccaccio (1313–1375), which enjoyed tremendous favor at the French court.
Boccaccio wryly recorded marital infidelities and sexual relations in *The
Decameron* and also in his more sober, moralizing writings such as *De casibus
virorum illustrium*. The latter text, which recounts the invariably unfortunate
fates of illustrious men and women in history, was the most beloved of Boccac-
cio's books in France in the vernacular translation during the fifteenth century,
and many copies were illuminated. In the one owned by John, Duke of Berry
(1340–1416), probably illuminated in 1410, a miniature illustrates the story of
the King of Lydia showing the extraordinary beauty of his naked wife, while

she is sleeping, to his favorite, Gyges. When the queen discovers what has transpired, she is so enraged that she orders Gyges to murder her spouse. The story is illustrated with a single miniature, which depicts the beautiful woman lying full length in the nude on her bed, even as her hands discreetly cover her groin and one breast (FIG. 2.10).

The taste of the Duke of Berry, a voracious patron of the arts, favored the female nude along with diverse forms of eroticism. Notably, most of this imagery resides in his devotional manuscripts. In the *Belles Heures* of the Duke of Berry the narrative of the life of Saint Catherine focuses on her idealized nude body (FIG. 2.11), revealing the same late medieval female type as rendered subsequently by Bourdichon. In two miniatures, one showing Catherine's torture (fol. 17), she is depicted nude from the waist up, with beautiful blonde hair, pale but supple flesh, high breasts, narrow shoulders, and wide hips: a proudly statuesque body for a virginal and virtuous saint.[23] More surprising is the predatory sexuality of a miniature showing Saint Peter the Hermit beholding a courtly beauty sliding her hand under the gown and along the thigh of a handsome young Christian man, a rarely depicted episode from the saint's life (fol. 191).[24] The explicit depiction of the illicit act makes the scene at least as titillating as it is potentially morally instructive.[25]

Just as Jean Bourdichon was a long-standing and loyal painter to the French crown, it is important to keep in mind that the Limbourg Brothers, the painters of both the *Belles Heures* and the *Très Riches Heures,* obtained their greatest commissions from the Duke of Berry. All three brothers seem to have

FIGURE 2.10
The Luçon Master, *The King of Lydia Showing His Naked Wife to Gyges* (detail). In Boccaccio, *De cas des nobles hommes et femmes,* 1410. Geneva, Bibliothèque publique et universitaire, Ms. fr. 190, fol. 74v

FIGURE 2.11
The Limbourg Brothers, *Empress Faustina Watching Saint Catherine Healed by Angels* (detail). *Belles Heures* of the Duke of Berry, 1406–8 or 1409. New York, Metropolitan Museum of Art, The Cloisters Collection, Acc. no. 54.1.1, fol. 17v

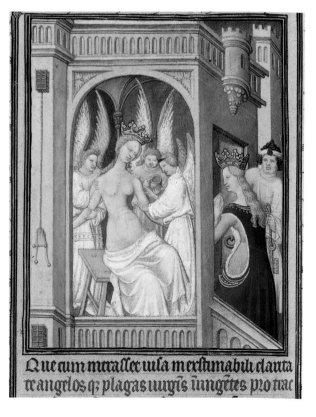

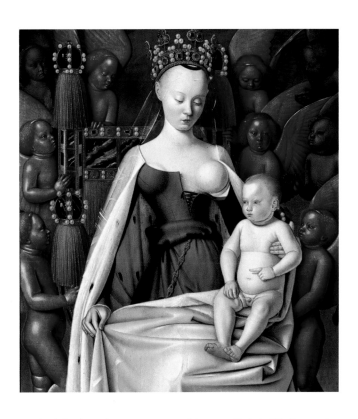

FIGURE 2.12
Jean Fouquet, *Virgin and Child*, ca. 1452–55. Oil on panel, 94.5 × 85.5 cm (37¼ × 33⅝ in.). Antwerp, Koninklijk Museum voor Schone Kunsten

worked for him for ten years, and in 1413 Pol de Limbourg became the ducal *valet de chambre*. Their closeness was manifest by a certain amount of playfulness between them, and they shared other interests that were considered provocative even in their time.[26] The duke's desire to take a twelve-year-old girl as his second wife aroused criticism among his peers, as did his efforts to arrange an eight-year-old wife for Pol de Limbourg over the angry objections of the girl's mother.[27] Indeed the tremendous success that Pol and his brothers enjoyed with the duke must have resulted not only from their talent but also from Pol's understanding of the duke's personality and his tastes and infatuations. Thus the roles of nudity and eroticism in the duke's books probably reflected larger appetites of their celebrated patron. They show the intimate ways in which a private devotional book might be personalized.

Related to this gallery of sensual female nudes in Valois manuscripts is a devotional image of another sort, Jean Fouquet's celebrated painting of the Virgin and Child in Antwerp (FIG. 2.12). It was intended for the tomb of Etienne Chevalier, the treasurer and close advisor of King Charles VII, and of his recently deceased wife, Catherine Budé, in the collegial church of Notre-Dame in Melun, where it remained visible for several centuries. The Antwerp Virgin belongs loosely to the genre of the *Virgo lactans*, in which the Virgin's breast is partially exposed while she breast-feeds the Christ child. Here, however, the child looks away, ostensibly oblivious to the voluptuous Virgin's perfectly formed and sensually rendered breast. The erotic charge that this Mary emits has long been remarked upon, and it is consistent with the seductiveness of the new type of Bathsheba.[28] Eroticism is likewise an undercurrent, if more subdued, in some of the popular variations on the Virgo lactans at this time.

Noteworthy is *Saint Bernard's Vision of the Virgin and Child*. According to legend, drops of milk from a statue of the Virgin miraculously landed on the saint's lips, which demonstrated that she truly is the Mother of God (FIG. 2.13). The Antwerp Virgin is part of a diptych, with its pendant showing a portrait of Chevalier kneeling in prayer, much the way Saint Bernard was shown before the Virgin in depictions of his vision.

Intriguing in the context of the present discussion is the long-standing identification of the model for Fouquet's Virgin as Agnes Sorel (1422–1450), La Dame-de-Beauté-sur-Marne. She was the mistress of King Charles VII, and mother of four of his children.[29] Perhaps equally significant for the cultural context of Bourdichon's Bathsheba, the king caused a scandal because of the property, riches, and public attention he lavished upon her, including her title. The image would have been posthumous, since it was painted in the 1450s, a few years after Sorel's death. If Sorel really was the model for the Antwerp Madonna, as seems likely, then the connection between art and life becomes inseparable.

Thus the sensual female nude developed a following, especially in the context of devotional art, among male patrons at the Valois courts in the fifteenth century. In the case of the Duke of Berry, these components appear to reflect larger personal tastes and predilections, while in Etienne Chevalier's devotional image for his tomb, they memorialize a legendary beauty who obtained a powerful position within the inner circle at the Valois court. (Chevalier was also the executor of Sorel's will, and a friend.) While Louis XII's Bathsheba

FIGURE 2.13
Simon Marmion, *Saint Bernard's Vision of the Virgin and Child*. Detached leaf from a devotional book, Valenciennes, ca. 1475–80. JPGM, Ms. 32

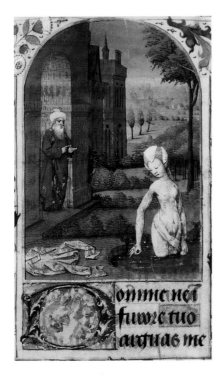

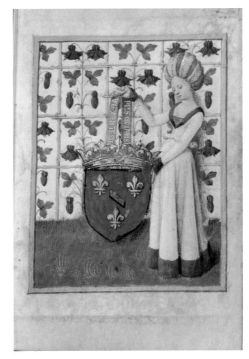

does not necessarily represent an identifiable model, historical circumstances at court may elucidate Bourdichon's conception of her.

BATHSHEBA BATHING IN THE SECOND HALF OF THE
FIFTEENTH CENTURY

None of the examples from the Duke of Berry's library cited here are as overtly erotic as Bourdichon's Bathsheba, the latter painted more than eighty years later. This type of Bathsheba, with her fully described genitalia, represents a further step in the presentation of the sensual female nude. Not surprisingly, however, the type of three-quarter-length nude Bathsheba in Bourdichon's large miniature was anticipated some decades earlier. The distinctive pose of Bourdichon's Bathsheba is found in mirror image as early as the 1460s in a book of hours illuminated by the Master of the Yale Missal, another follower of Fouquet (FIG. 2.14).[30] Although a transparent veil is draped over her groin, her pudenda remain visible, and she is submerged in water only up to her thighs, not to her hips. This Bathsheba is also more modest, with her head tilted down and away from both David and the viewer. Her illuminator depended regularly on Fouquet's workshop patterns, and it is very likely that here, too, he was copying a design for a now-lost female nude, almost certainly representing Bathsheba, by the great master. The turban worn by the Yale Master's graceful Bathsheba crowns the figure dramatically, neatly counterbalancing the broad curves of her hips in a manner lacking in Bourdichon's interpretation, but wholly characteristic of Fouquet. Fouquet often crowned with turbans the heads of the beautiful young women he depicted (FIG. 2.15).

Moreover, the figure's perfectly ovoid head and the resulting exquisite silhouette recall his art, too (see FIGS. 3.13, 3.14). Given the majestic beauty and

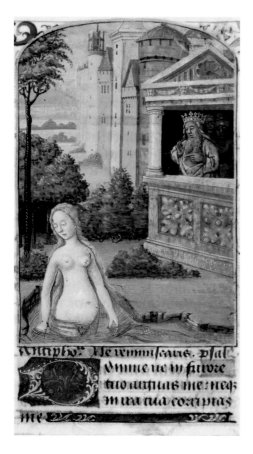
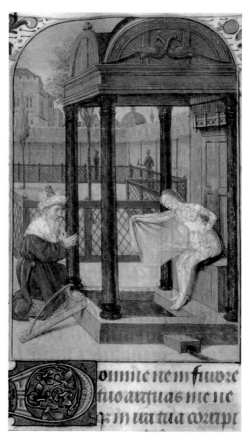

erotic power of the Antwerp Virgin, it would not be surprising to find that Fouquet himself had created an exquisitely sensual new type of bathing Bathsheba. The pose in figure 2.14 was repeated closely and often for the rest of the century, not exclusively, but especially, by followers of Fouquet, such as the Master of Jean Charpentier (FIG. 2.16).[31] The apparent source in Fouquet also helps to define what is so original about Louis XII's Bathsheba. She is not only physically larger within the image (itself large) and still closer to the front of the space but also more self-conscious, coy, and seductive. With her radiant and abundant blonde hair, she embodies more fully the temptress and exhibitionist described by de la Tour Landry. She has something of the quality of the modern pinup.

In the second half of the century, the bathing Bathsheba was depicted by a broad range of French illuminators in a variety of forms, but nearly all of them share an interest in her sensual character and show her as a statuesque figure. Many of these were made specifically for male patrons, while one that was made for a woman represents an uncovered Bathsheba who, however, discreetly drapes her crotch.[32] (When Bourdichon turned to illuminating a sumptuous book of hours for Louis XII's second wife, Anne of Brittany, she deemed the familiar subject of David in penance more appropriate to represent the Penitential Psalms.) In one unusual, bawdy, and droll interpretation of the story, David appears before Bathsheba at the fountain, and she opens her towel to reveal her full nudity (FIG. 2.17).[33] His gaze is rapt, and his hand covers his

FIGURE 2.16
The Master of Jean Charpentier, *Bathsheba Bathing* (detail). Book of hours, Tours, ca. 1475. New York Public Library, Ms. 150, fol. 62

FIGURE 2.17
Follower of Fouquet, *Bathsheba Exposing Herself to King David*. Book of hours, 1460s. Moscow, State Historical Museum, Muz. 3688, fol. 14

heart in response.[34] He appears to fall to his knees, parodying the standard pose of the penitent David. Bathsheba does not expose herself so much for us as for him—and with a flourish. Significantly, this miniature derives from a follower of Fouquet, a reflection perhaps of the favor Fouquet and his followers enjoyed with the court circle.

LOUIS XII'S BATHSHEBA AND THE DISSOLUTION OF HIS MARRIAGE

On April 7, 1498, King Charles VIII, who had been in frail health, died at the age of twenty-seven without a male heir. Nine days later, his cousin, Louis of Orleans, was proclaimed King of France and, on May 27, crowned at Reims. Louis loathed his wife, Jeanne, for her physical disabilities and in order to secure the prized duchy of Brittany, sought to marry Charles VIII's widow, Anne of Brittany. In fact at the time of their marriage, Charles and Anne had signed an agreement that, were Charles to die without a proper heir, Anne would marry his successor. Louis had endeavored to have his own marriage annulled repeatedly over the years without success. Now, in order to wed Anne, Louis needed to try again and during the summer set about to obtain the necessary papal dispensations. In the proceedings of the annulment, which culminated successfully this time, on December 17, 1498, Louis XII repeatedly swore that he had never had sexual relations with Jeanne, a vow that he reiterated throughout the proceedings, in the face of her insistence that they had.[35]

Whether or not he enjoyed connubial relationships with his long-suffering wife, he certainly had had many extramarital sexual adventures. These are confirmed by numerous reports, including records of payments to *filles de joie*.[36] Such behavior was typical in the Valois line, many members of whom were more happily married than poor Louis.[37] Indeed, Charles VIII was famously licentious. Large groups of female servants, including prostitutes, accompanied Charles's troops to Naples on his Italian campaign of 1494–95, a campaign in which Louis played a significant role. Charles was known for picking up women along the way, including well-born mistresses and favorites who would travel with him. (Despite his many infidelities, Anne of Brittany, who bore him six children, still expressed great sorrow at her husband's death.) Noteworthy for Louis' infidelities is the aforementioned papal nuncio's report in November 1498 that appeared in the course of the annulment proceedings, of his continued indulgence in "lascivious" pursuits. While his marriage to Anne of Brittany, solemnized on January 8, 1499, proved much happier for him and quite successful, the reports of his extramarital affairs continued.[38]

Louis XII's seductive miniature, showing a voluptuous, blonde Bathsheba at her bath, must have given him great pleasure. Its explicit titillation would have flattered his love of women. Bathsheba presents herself even more openly to Louis the viewer than she does to King David, who only sees her from behind—in the distance—her long hair discreetly covering her posterior. In *Bathsheba Bathing* Bourdichon may even have inserted some bawdy humor to delight the king. The head of the feline creature that serves as a waterspout takes a hard look at the resplendent bather. In sixteenth-century slang, *chatte* (cat)

meant "prostitute," an allusion that is not likely to have escaped the book's randy patron.[39] In the art of previous centuries, Bathsheba had embodied different meanings and held a more profoundly spiritual significance, including comparisons with Ecclesia and Eve. Louis may still have been aware of some of these symbolic associations. Moreover, the larger narrative of David and Bathsheba had long held significance for the ruling class, especially in France. The book of hours made for the adolescent Anne of France—the future Anne of Beaujeu—presents a more demure Bathsheba and emphasizes her future as queen and the noble sacrifice of her husband, the loyal soldier Uriah. It seems likely that Louis XII understood, too, the view evident in literature since the thirteenth century that Bathsheba was not a passive agent, but the seducer of David, capable of exercising her feminine wiles. By the later Middle Ages Eve herself had come to be viewed ever more pointedly as a seductress. In the fifteenth century, at least in courtly books of hours and other devotional court art, the spiritual conflates with the sensual.

The type of the resplendently naked, voluptuous Bathsheba occupies a significant place in the history of the nude in European art. In the second half of the fifteenth century in France, it was the most popular manifestation of the wider phenomenon of the sensual female nude. From the first years of the century, the latter genre enjoyed particular favor with Valois court patrons. The taste for titillating imagery among certain Valois, even within a spiritual context, may be loosely correlated with their own sexual appetites. (Many Valois rulers in the fifteenth century were notable for their libidos as well as their cultivated artistic tastes.) That the female nude seemed to gain popularity first in manuscripts may have resulted from the fact that books have a relatively intimate and private character.

Clearly the sensual Bathsheba demonstrates one of the myriad ways a luxury book of hours could be personalized to the taste of a patron, in this case a male patron. Moreover, this type of David's celebrated consort was likely invented at the French court, probably by Jean Fouquet, known for innovative erotic imagery. Fouquet was the painter of Charles VII and subsequently of Louis XI and was the one from whom Bourdichon both learned his art and inherited his position at court, where the popularity of the sensual nude would only grow. Soon the impact of the Italian High Renaissance in France would further elevate the place of the female nude, as evidenced by the erotic (and wholly secular) imagery of the frescoes at Francis I's Fontainebleau. Bourdichon's playful Bathsheba anticipates the new attitude of overt sexuality. It is the most beautiful and alluring illumination that survives of its genre, a supreme example of his art that sheds light on a provocative aspect of the art and court culture of its time.

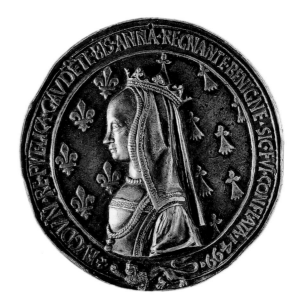

ABOVE:

Nicholas Leclerc and Jean
de Saint-Priest, *Louis XII,
King of France and His
Queen, Anne of Brittany*,
1499. Commemorative
medallion. Bronze, diameter:
113 mm (4⁷⁄₁₆ in.). Los Angeles
County Museum of Art; pur-
chased with funds provided
by the Mira T. Hershey
Collection

NOTES

I am grateful to Ann Jensen Adams, Mark Evans, Christopher Hughes, and Erik Inglis for reading a draft of my essay and for their thoughtful and learned suggestions to improve it.

1. Y. Labande-Mailfert, *Charles VIII: Le Vouloir et la destineé* (Paris, 1986), p. 472.

2. Ibid. See also R. Maulde la Clavière, *Histoire de Louis XII,* vol. 3 (Paris, 1885), pp. 341–42, 378–80.

3. Frederic Baumgartner, *Louis XII* (Scranton, Pa., 1994), p. 80.

4. William S. Voelkle and Roger Wieck, *The Bernard H. Breslauer Collection of Manuscript Illuminations,* exh. cat. (New York, 1992), p. 76.

5. Paul Saenger, "Silent Reading: Its Impact on Late Medieval Script and Society," *Viator* 13 (1982), pp. 412–13.

6. Janet Backhouse, *The Bedford Hours* (London, 1990), p. 5, see also color plate 22.

7. See, e.g., Benedicta J. H. Rowe, "Notes on the Clovis Miniature and the Bedford Portrait in the Bedford Book of Hours," *Journal of the British Archaeological Association,* 3rd ser., 25, 1962, pp. 56–65.

8. Ernst Trenkler, *Livre d'heures: Handschrift 1855 der Österreichischen Nationalbibliothek* (Vienna, [1948]), p. 7.

9. François Avril, *Jean Fouquet: Peintre et enlumineur du XVe siècle,* exh. cat. (Paris, 2003), pp. 345–48. François de Vendôme was not the book's first owner, but he acquired it most likely within a generation of its creation, probably from the first owner, almost certainly someone within his circle close to the king.

10. Paris, Bibliothèque nationale de France, Ms. lat. 10532; Nicole Reynaud in François Avril and Reynaud, *Les Manuscrits à peintures en France, 1440–1520,* exh. cat. (Paris, 1993), pp. 296–97, no. 163.

11. Curiously, a tapestry in gold and blue is hung behind them with the initials *A* and *V* bound in the love knot associated with a married couple. The initials might be interpreted as those of Aha-suerus and Vasthi, the former's queen before his marriage to Esther (Pierpont Morgan Library type-script description of M. 677 available in their reading room), but such a subject seems inappropriate

in the context of the larger cycle of miniatures related to the David and Bathsheba narrative in the Penitential Psalms.

12. Elizabeth Kunoth-Liefels, *Über die Darstellungen der "Bathsheba im Bade": Studien zur Gechichte des Bildthemas 4. bis 17. Jahrhundert* (Essen, 1962), pp. 12–14; Eric Jan Sluijter, "Rembrandt's Bathsheba and the Conventions of a Seductive Theme," in Ann Jensen Adams, ed., *Rembrandt's Bathsheba Reading King David's Letter* (Cambridge, U.K., 1996), p. 83; see Harvey Stahl, "Bathsheba and the Kings: The Beatus Initial in the Psalter of Saint Louis," in F. O. Büttner, ed., *The Illuminated Psalter* (Turnhout, Belgium [2005]), pp. 322–24, 326–27. I am grateful to Christopher Hughes and Marissa Moss for providing me with a copy of the article in galleys.

13. Stahl 2005. See esp. his complex and carefully reasoned interpretation of the image in the psalter, pp. 321–28.

14. Stahl (2005), p. 326.

15. Andrei Sterligov, *Livre d'heures de Louis d'Orléans*, facs. ed. (Paris, 1981); François Avril, *Livre d'heures enluminé par Pelerin Frison, peintre des Capitouls dans les années 1500* (Toulouse, 2003), pp. 59–62.

16. See, e.g., the woodcut of *The Fall of Man* by Hans Baldung Grien of 1511. See Joseph Leo Koerner, "The Mortification of the Image: Death as a Hermeneutic in Hans Baldung Grien," *Representations* 10 (1985), pp. 54, 85; and James Marrow, "Symbol and Meaning in Northern European Art of the Late Middle Ages and the Early Renaissance," *Simiolus* 16 (1986), pp. 166–67.

17. "David en fist faulx jugement ... Il n'est rien que femme n'assote," quoted from *Li Trèsors* by Kunoth-Liefels 1962, p. 15.

18. "Si se lavoit et pingnoit à une fenestre dont le roy povoit bien veoir; sy avoit moult bien chief et blont. Et par cela le roy en fut tempté et la manda ... Et ainsi pecha le roy David doublement, en luxure et en homicide ... Et tout ce pechié vint pour soy pingniere et soy orgueillir de son beau chief. Sy se doit toute femme cachier...ne ne se doit pas orguiller, ne monstrer, pour plaire au monde son bel chef, ne sa gorge, ne sa poitrine, ne riens qui se doit tenir couvert." Anatole de Montaiglon, *Le livre du Chevalier de la Tour Landry pour l'enseignement de ses filles, publie d'aprés les manuscrits de Paris et de Londres* (Paris, 1854), pp. 154–55. I am grateful to Gabrielle Spiegel for her help with my translation from the French.

19. M. Tuetey, "Inventaire des biens de Charlotte de Savoie," *Bibliothèque de l'École des Chartes*, 26 (1865), p. 361; Joseph Barrois, *Bibliothèque protypographique, ou librairies des fils du Roi Jean: Charles V, Jean de Berri, Philippe de Bourgogne, et les Siens* (Paris, 1830), p. 156, no. 991; and H. Omont, *Anciens inventaires et catalogues de la Bibliothèque nationale*, vol. 1 (Paris, 1908), p. 12, no. 83.

20. Kunoth-Liefels 1962, fig. 16.

21. Brigitte Buettner has argued that the female nude in France did not, as has sometimes been assumed, emerge from the renewed interest in ancient sculpture that helped shape the interest in the nude in Renaissance Italy as much as from other factors. "Dressing and Undressing Bodies in Late Medieval Images," in Thomas Gaehtgens, ed., *Künstlerischer Austausch; Akten des XXVIII. Internationalen Kongresses für Kunstgeschichte, Berlin, July 15–20, 1992*, vol. 2 [Berlin, 1993], pp. 383, 388).

22. The Valois line, a cadet branch of the Capetians to which Saint Louis belonged, ruled France from the late fourteenth to the late sixteenth century. In the fifteenth century their members included the Dukes of Burgundy and Berry.

23. See Buettner's acute analysis of these images in Buettner 1993, pp. 386–87.

24. Ibid., fig. 8.

25. A curious counterpart to the female sensuality in the duke's books is the male sensuality, with its focus on the male erogenous zone, in the famous *Très Riches Heures*. On this, see Michael Camille, "'For our Devotion and Pleasure': The Sexual Objects of Jean, Duc de Berry," in M. Camille and A. Rifkin, eds., *Other Objects of Desire: Collectors and Collecting Queerly* (Malden, Ma., 2001), pp. 7–32. In a provocative argument Camille relates this imagery to the duke's reputation for infatuations with working-class men. He also shows that the erogenous zones of both men and women were represented both frankly and wittily in the duke's book of hours.

26. Camille 2001, pp. 18–19.

27. Ibid., pp. 9, 12, 18–19.

28. Johan Huizinga, *The Autumn of the Middle Ages*, trans. by Rodney J. Payton and Ulrich Mammitzsch (Chicago, 1996), p. 182.

29. While the identification has never been proven and dates only to the early seventeenth century, it has been widely accepted. See, most recently, Avril 2003, pp. 128, 130, 149.

30. Liudmila Kiseleva, "Neizvestmaia rukopis' iz masterskoi Zhana Fuke?" *Pamiatniki kul'tury. Novye otkrytiia* (1978), pp. 233–41; and the forthcoming French edition of the catalogue of the Russian Academy of Sciences by Kiseleva. Patricia Stirnemann kindly showed me a copy of the entry on that manuscript.

31. John Plummer, *The Last Flowering: French Painting in Manuscripts, 1420–1530*, exh. cat. (New York, 1982), p. 45, cat. no. 60, pl. 60. The group of artists associated with the Master of Guillaume Lambert, who were not, strictly speaking, Fouquet followers but who had access to his workshop models, also used it repeatedly, e.g., in books of hours in the Bibliothèque nationale de France, Ms. n. a. lat. 3117, fol. 91, and in the Bibliothèque municipale, Rouen, Ms. 3027 (Leber 41), fol. 86; Elizabeth Burin, *Manuscript Illumination in Lyon, 1473–1530* (Turnhout, Belgium, 2001), color pl. IV and fig. 56, resp.; and also by an anonymous illuminator in a *Bible moralisée* (Bibliothèque nationale de France, Ms. 166, fol. 76v); Kunoth-Liefels 1962, fig. 10a. The pattern also was employed in a book of hours that, according to François Avril, may be one of Bourdichon's earliest works (sale, Drouot, Paris, May 17, 1974, lot 37). I know it only in a reproduction from the catalogue that M. Avril kindly drew to my attention.

32. Examples of the former are the Hours of Claude Molé, Lord of Villy-le-Maréchal, near Troyes (New York, Pierpont Morgan Library, M. 356, fol. 30v), Plummer 1982, pp. 90–91, cat. no. 116; and the Hours of Nicolas Séguier, Lord of l'Estand-la-Ville and Saint-Cyr (Chantilly, Musée Condé, Ms. 82 [1400], fol. 84), Kunoth-Liefels 1962, fig. 11. An example of the latter is the Hours of Marguerite de Coëtivy (Chantilly, Musée Condé, Ms. 74 [1088], fol. 61), Edward Lucie-Smith, *Sexuality in Western Art* (London, 1991), p. 41, fig. 38. I am grateful to Isabelle Delaunay for her confirmation of the identification of the patron of the Séguier hours.

33. Ekaterina Zolotova, *Books of Hours: Fifteenth-Century French Illuminated Manuscripts in Moscow Collections* (Leningrad, 1991), p. [42].

34. The complementary theme of voyeurism in this miniature has a witty counterpart in a Bathsheba miniature in another French book of hours, where in the bas-de-page the prone, defeated Goliath is still alert enough to gaze up to Bathsheba, a long club in his hand rising suggestively (Walters Art Museum, W. 245, fol. 31). See Lilian M. C. Randall, *Medieval and Renaissance Manuscripts in the Walters Art Gallery: France, 1420–1540*, vol. 2 (Baltimore and London, 1992), p. 324, fig. 295.

35. Baumgartner 1994, p. 395.

36. His biographer, Claude de Seyssel, wrote "en son jeune et florissant aage nourry plutôt en lubricité et lascivité. . . ." *Histoire singuliere du roy Loys XIIe* (Paris, 1558), fol. 45; see also Georges Minois, *Anne de Bretagne* (Paris, 1999), p. 391, and Baumgartner 1994, pp. 10–11, 22, 46, 50.

37. The Valois Duke of Burgundy, Philip the Good (r. 1419–67), had as many as fifteen illegitimate children, a number of whom grew up to obtain positions in his government and that of his legitimate son and heir, Charles the Bold. He probably had at least twenty mistresses (Richard Vaughn, *Philip the Good: The Apogee of Burgundy*, rev. ed. [London and New York, 2002], pp. 132–33).

38. Minois 1999, p. 423, discusses a Genoese mistress that the king maintained in Lombardy in 1502.

39. I am grateful to Mark Evans for drawing this to my attention along with the following reference: Edmond Huguet, *Dictionnaire de la langue Français du seizième siècle* (Paris, 1932), vol. 2, p. 223 as "Femme de mauvaise vie."

The Manuscript Painting Techniques of Jean Bourdichon

NANCY TURNER

Jean Bourdichon ranks as one of the major French illuminators of his generation and was a powerful influence on book painting of his time. Yet his painting techniques have never been fully described, nor have his works been the subject of a technical investigation. Widely regarded as a conservative artist, Bourdichon employed a style that is most frequently characterized by a predilection for gold highlighting upon draperies, the use of half-length compositions, nocturnal scenes, and a prodigious (yet often repetitious) workshop output.[1]

In this preliminary investigation, focusing largely on works from the collection of the J. Paul Getty Museum, the painting techniques of Jean Bourdichon will be described by considering his mature work from the surviving leaves of the Hours of Louis XII. Where appropriate, two other manuscripts from the Getty's collection, one of Bourdichon's earliest manuscripts, the Katherine Hours (ca. 1480–85; FIGS. 1.3, 3.19, 3.27); and the Hours of Simon de Varie (1455; FIG. 1.7), by Bourdichon's mentor, Jean Fouquet; and several other leaves from the Hours of Louis XII not in the Getty's collection will also be brought into the discussion.[2] Recent scientific analysis to characterize the pigment palette and to investigate the underdrawing will augment the discussion of the three leaves acquired by the Getty in 2003.[3] These three leaves, *Louis XII of France Kneeling in Prayer, Accompanied by Saints Michael, Charlemagne, Louis, and Denis* (PL. 1), *Bathsheba Bathing* (PL. 18), and *The Presentation in the Temple* (PL. 13) represent, respectively, Bourdichon's approach to portraiture, his treatment of the female nude, and an example of a fairly typical devotional image. Thus, from these and a selection of other surviving leaves from the Hours of Louis XII, Bourdichon's manuscript painting techniques can begin to be characterized, including his use of underdrawing and pigment mixtures, his methods for painting facial features and draperies, his interests in lighting effects and color, and his techniques for conveying spatial recession.

PRESENCE OF UNDERDRAWING

Bourdichon appears to have underdrawn his compositions in a liquid medium (not a dry medium like a metalpoint or chalk) in the Hours of Louis XII.[4] In all

63

FIGURES 3.1A AND 3.1B
Details from Plate 18. Infrared
reflectograms. Courtesy of
Yvonne Szafran, Department
of Paintings Conservation, the
J. Paul Getty Museum.

three Getty leaves, some minor compositional changes have been detected using infrared reflectography (IRR).[5] For instance, in *Bathsheba Bathing* a few irregular diagonal lines appear in the area to the left of Bathsheba's right arm in the infrared reflectogram (FIG. 3.1A), which are not reflected in the paint layer. Moreover, Bourdichon laid in fewer trees in the drawing stage: the narrower, darker trees behind Bathsheba at upper right have a different appearance in the reflectogram (FIG. 3.1B), suggesting that they were added at the painting stage to make a denser group.[6] Aspects of Bathsheba's form were changed slightly in the paint layer; in particular her right shoulder was sloped a bit more steeply, and her waist was slightly narrower at the arch of her back.

Additional underdrawn lines in the other two Getty miniatures, made apparent by IRR, include adjustments to the position of the Christ child in *The Presentation in the Temple* (FIG. 3.2). Also, the illuminator painted the image before rendering the frame, for the uneven ends of the vertical strokes of the architectural background at the upper right were covered by the painted frame. In *Louis XII of France Kneeling in Prayer*, slight changes in the position of the miter of Saint Denis (figure at right) can be detected, and loose indications of a curlier beard and hair appear in the head of Charlemagne (third standing figure from right). To indicate volume and shadow, hatching can be seen in the neck of Saint Louis (second from right) and in the legs of the king (kneeling figure). The shadow beneath the pillow on which Louis' knees rest and the drapery of Saint Denis is laid in more broadly than what is visible on the surface. Thus, the IRR reveals evidence that Bourdichon made slight modifications to his designs as he worked.

THE PIGMENTS IDENTIFIED

In the Getty Museum's three leaves from the Hours of Louis XII, Bourdichon's palette consisted of about a dozen pigments and colorants, as have been identified thus far by recent technical analysis using X-ray fluorescence (XRF)

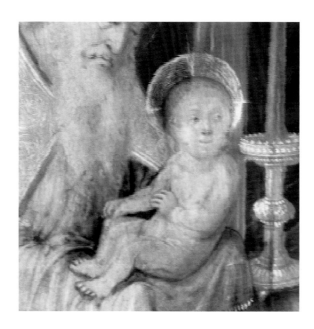

spectroscopy and Raman spectroscopy.[7] No samples were removed from the three miniatures during the course of the study; XRF and Raman spectroscopy are noninvasive techniques used for the identification of pigments. From *Louis XII of France Kneeling in Prayer*, *Bathsheba Bathing*, and *The Presentation in the Temple*, the following materials were identified: lead white, ultramarine blue, malachite, azurite, vermilion, yellow ocher, lead tin yellow (type I), painted gold, painted silver, carbonaceous black, and bismuth black. An organic pink is evident, though it has not yet been positively identified, nor could the binding media be determined with the present methods. What became clear from the pigment analysis was that Bourdichon rarely used a pure pigment but, rather, created pigment mixtures for every element within his compositions.

Lead white was perhaps the most ubiquitous pigment found in the three leaves, for Bourdichon appears to have added lead white to nearly all his pigments as well as used it for areas of white. For flesh tones, he added vermilion, ultramarine, and azurite to white, as in the shadows on the left side of Bathsheba's torso (FIG. 3.3) and face (FIG. 3.16). It is no wonder that Bourdichon's figures are often imbued with an overall coolness, for his flesh tones, including facial tones, were found to have mineral blue added to them.

Bourdichon seems not to have reserved the use of ultramarine blue only for areas of pure blue. In fact, even in the darkest blue robes, he mixed ultramarine with white and reserved the purest blue for the shadow lines within the folds of the Virgin's robe in *The Presentation in the Temple* (see FIG. 3.21). Ultramarine was also the blue pigment of choice for sky and landscape elements. It was even used in admixtures to create a brown ground-tone on which King Louis XII and the saints stand, and in the dusky mauve-gray architectural background in *The Presentation in the Temple* (PL. 13). Thus, Bourdichon does not treat ultramarine as a particularly precious or costly material; he apparently used it in color mixtures of every sort.

 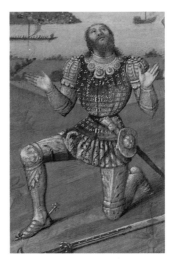

Azurite was detected in admixtures with lead white to depict Saint Denis' miter and with lead white and ultramarine for Charlemagne's beard (FIG. 3.10).[8] Malachite was identified as the green pigment, mixed with lead white, used for the wings of Saint Michael in *Louis XII of France Kneeling in Prayer* and the green altar front in *The Presentation in the Temple*. Vermilion was used in areas of pure red, magenta (where it is mixed with lead white and an organic pink), as well as in flesh tones (admixtures of lead white), and in browns. Vermilion was also probably used to warm up the golden background color of the brocaded fabrics. Lead tin yellow (type I) was positively identified by Raman spectroscopy in the hair of the Christ child and in the candles on the altar from *The Presentation in the Temple*. Bourdichon apparently chose lead tin yellow for its relatively cool tonality for selective details. An iron-containing yellow, presumably yellow ocher, however, was used for its warm hue in such mixtures as the golden brocades and in brown admixtures.

Bourdichon made strikingly effective use of painted gold in the brocaded fabrics, using granulated gold, perhaps some amount of vermilion, probably yellow ocher, and even ultramarine for the base layer. He then painted patterns and details with an unadulterated, reflective granular gold, such as the sunburst designs across King Louis' garment (FIG. 3.4). The contrast between the more matte golden ocher undertone with the more reflective pure gold on top was undoubtedly inspired by Jean Fouquet, as in, for example, the golden armor and architectural details found in the Hours of Etienne Chevalier (FIG. 3.5). Inspiration for this use of contrasting golds might also be found in the flower-strewn borders in contemporary Flemish manuscripts.

In addition to his use of granular painted gold, Bourdichon made limited use of painted silver for the depiction of very specific elements in his designs. Silver paint was used to delineate the ripples of water encircling Bathsheba's legs. This silver has darkened significantly from exposure to atmospheric pollutants and today appears black, whereas its original appearance would have been lighter in value and highly reflective (see FIG. 2.1). Bourdichon also employed silver paint to depict the metal armor worn by King Louis XII. In his legs and

FIGURE 3.4
Detail from Plate 1

FIGURE 3.5
Jean Fouquet, *David in Prayer* (detail). Hours of Etienne Chevalier, ca. 1452–61. London, The British Library, Add. Ms. 37421

FIGURE 3.6
Detail from Plate 1

arms, the silver is painted alongside and on top of ultramarine blue, retaining just a few areas of its original reflectance (FIG. 3.6).[9] Perhaps Bourdichon's most effective uses of metallic pigments are to be found in the contrasting gold and silver zodiacal figures on the deep blue background in the four calendar miniatures (PLS. 2–5), a technique he continued to employ in the Hours of Anne of Brittany's calendar miniatures (see FIG. 1.12).

The greatest surprise from the pigment analysis was the identification of bismuth black used in the dark brownish black or gray-mauve areas of the illuminations. Not typically known as a manuscript illumination pigment, bismuth was detected in all three of the Getty miniatures using XRF.[10] Though most fifteenth-century pigment recipes that include bismuth metal were intended for silvery, metallic inks and grounds, Bourdichon did not use bismuth pigment to replace metallic silver paint.[11] Rather, he employed the pigment for its warm gray qualities in the mauve-gray shadowed architectural background (FIG. 3.7) in *The Presentation in the Temple*, and for the dark gray trees (FIG. 3.8) in the garden behind Bathsheba in *Bathsheba Bathing*. In fact, the trees painted with bismuth appeared characteristically dark black in IRR,[12] while the smaller trees and outlines added in a carbon-containing brown appear paler in IRR (FIG. 3.1B).

Thus, Bourdichon's palette can be characterized by his predilection for mixtures in all passages. He employed two types of blue (azurite and ultramarine), yellow (yellow ocher and lead tin yellow), red (vermilion and an organic red), and gold (a matte golden admixture and reflective pure gold), choosing one over the other for its specific tonality. Bourdichon made particularly effective use of metallic silver and gold pigments, and he even employed an unusual metallic bismuth black for warm gray-brown passages in a way that departed from that pigment's traditional use.[13]

PAINTING FACIAL FEATURES

Scholars have noted a range in artistic quality among the facial features within Bourdichon's work, raising the questions of workshop practice, secondary hands, and in particular whether a specialist in portrait illumination might have been called upon to paint donor or royal portraits.[14] While these questions may never be fully answered, technical analysis can begin to address the matter. For a painter who used variegated pigment admixtures in all passages, what can be said is that no major departure from this basic palette can be detected in any of the faces in the three Getty leaves. In fact, technical unity can be observed between those of the most fine and least fine quality. What may account for the range in quality or, rather, degree of finish may be the result of a relative hierarchy of importance among the figures.

For instance, the face of King Louis XII is by far the most layered and highly worked of any in the surviving leaves from the manuscript (FIG. 3.9). As he did with the face of Anne of Brittany in her Hours (see FIG. 1.2), Bourdichon applied all his attention and skill to the royal portrait, using multiple layers of perhaps a half-dozen tonal variations, including pink, yellowish tan, red-orange, pale gray, medium gray, light brown, and medium brown. These

FIGURE 3.7
Detail from Plate 13.
Photomicrograph of bismuth pigment (particle at center) in architectural background.

FIGURE 3.8
Detail from Plate 18

hues were painted and overlapped in a fine network of long, curved, hatched, and crosshatched strokes over the entire surface of the face, with a few stipples of gray and red at the near cheek. By contrast, in *Louis XII of France Kneeling in Prayer*, the faces of the saints surrounding the king are rendered with a more simplified, less highly worked method. As an example, Charlemagne's face (FIG. 3.10) is painted with a broad undertone in a tan flesh color, with shadows down-modeled with strokes of light brown and gray, and subsequent parallel hatching added in red at the cheeks, nose, lips, and eyelids, as well as the fingertips and knuckles of the hands to enliven these features. Strokes of opaque pale pink are applied last to modify and soften some of the brown and gray shadows. Final articulation of the facial features and outlining of the profile are made in a brownish gray pigment. In contrast to Louis, the aged male faces of such secondary figures as Charlemagne or Saint Denis (FIG. 3.11) are depicted by Bourdichon with a quick yet sympathetic brush, while giving a summary treatment to facial details.

This hierarchical approach is reminiscent of Jean Fouquet's pattern for the rendering of the faces in the opening miniatures in the Hours of Simon de Varie (see FIG. 1.7). For instance, the female heraldic figure (FIG. 2.15) is painted quite economically with a lightly tinted, transparent yellow-gray glaze for the underlying flesh tone and a fine network of light gray stipples to model the face (FIG. 3.14). Only a slight tint of pale pink was added to the lips and cheeks to warm the flesh of the otherwise sculptural figure. The face of the Virgin (FIG. 3.13), by contrast, is rendered first with a pinkish flesh tone, the shadows down-modeled with fine, short parallel hatches and stipples in two dilutions of a dark blue-gray colorant, with touches of red added to the lips, nostrils, eyelids, ears, and cheeks, and final outlining of facial features articulated in brown. Fouquet devoted the greatest attention to the portrait of the donor, Simon de Varie (FIG. 3.12).[15] Unlike his work on canvas and panel, and more like his drawing technique, Fouquet used a dense network of unblended strokes to build up color layers.[16] Covering the entire surface of the face with fine strokes and stipples, he used light brown and dark brown inks, then modeled with varying values of red pigment, followed by thin gray strokes to modify and partially mute the red and brown tonalities. A small touch of mineral blue was applied within Simon's eye socket to give a contrasting accent shadow. The density of strokes and number of layerings are remarkable in the donor portrait, for under binocular magnification, the surface appears like a woven textile, making the progression of layers difficult to ascertain. Thus, looking at the three facial types in Fouquet's miniatures in the Hours of Simon de Varie, one might suggest that there was a technical progression towards complexity, from the least descriptive but subtly glazed heraldic females, to the Virgin rendered with cool shadows and touches of pink to enliven her features, to the highly worked face of the donor. Though Bourdichon did not directly imitate Fouquet's painting technique, he did seem to approach his figures within a hierarchy by lavishing more attention with the brush and sharpening his descriptive focus on the portrait heads, an approach that is understandable and may be more widespread, given the expectations of demanding patrons.

FIGURE 3.9
Detail from Plate 1

FIGURE 3.10
Detail from Plate 1

FIGURE 3.11
Detail from Plate 1

FIGURE 3.12
Jean Fouquet, *Simon de Varie Kneeling in Prayer* (detail; fig. 1.7). Hours of Simon de Varie, 1455. JPGM, Ms. 7, fol. 2

FIGURE 3.13
Jean Fouquet, *The Virgin and Child Enthroned* (detail; fig. 1.7). Hours of Simon de Varie, 1455. JPGM, Ms. 7, fol. IV

FIGURE 3.14
Jean Fouquet, *Female Heraldic Figure* (detail; fig. 2.15). Hours of Simon de Varie, 1455. JPGM, Ms. 7, fol. 1

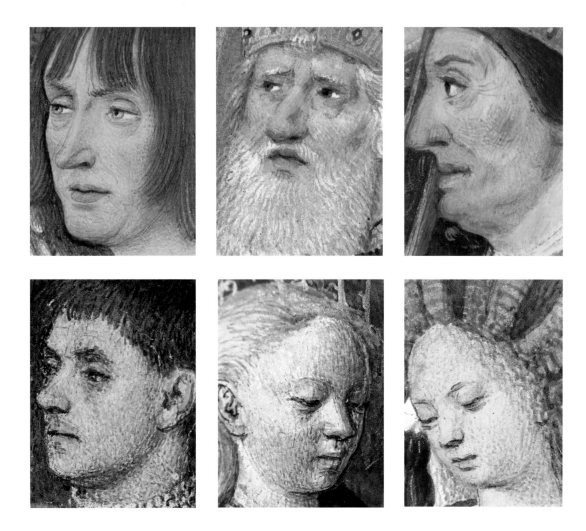

In similar fashion, the idealized face in the British Library's miniature of *The Virgin of the Annunciation* from the Hours of Louis XII received particular attention from the artist and ranks among his highest-quality work (PL. 9 and FIG. 3.15). Being the first illustration to the Hours of the Virgin, the Annunciation image often received the most attention and was, therefore, one of the most carefully painted miniatures in a devotional book. In *The Virgin of the Annunciation* from the Hours of Louis XII, Bourdichon used multiple layering of closely allied pale hues to build up a highly finished paint surface (FIG. 3.15). While giving to the unaided eye the impression of being blended like oil, Bourdichon's brushwork achieved an extraordinary subtlety and unity across the gradation of tones in the Virgin's face by using fine parallel strokes on top of a pale, slightly cool-colored base flesh tone and, particularly, by his use of a partial gray undertone and gray shadows in her face, neck, and hands. A blush to the Virgin's cheek, nose, lips, chin, earlobes as well as her fingertips was made with very fine strokes of red. Slightly blue tinted shadows were painted beneath the Virgin's eyes, yet these shadows were modified with very short vertical, parallel strokes of white to soften and reduce the impact of the blue shadow. A restrained use of brownish black pigment was used in very

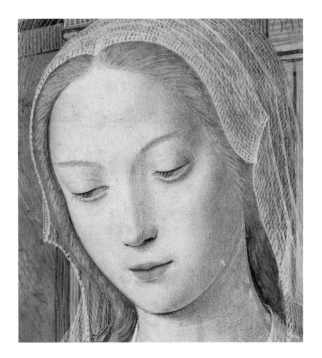

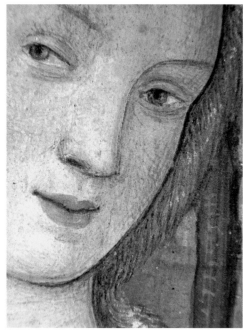

specific areas to give final definition between the lips, under the edge of the nose, and along the upper eyelids of her downcast gaze. Even the Virgin's eyebrows and eyelashes were modeled in exceedingly fine strokes of painted gold. Compared to Jean Fouquet's rendering of the Virgin from the Hours of Simon de Varie (FIG. 3.13), which is painted with a mosaic of stipples and daubs of color, Bourdichon's technique of modeling with long parallel strokes in a color very close to the base tone lends an enamel-like smoothness and a subtle transition from light to shadow, and hence gives a beautiful luminosity to the flesh tone of the Annunciate Virgin's face in the Hours of Louis XII.

The face of Bathsheba presents another example of Bourdichon's idealized female face (FIG. 3.16): a flesh tone of lead white is mixed with vermilion and ultramarine as a base layer, and a thin layer of blue is applied to create a subtle shadow along the side of her face as well as her torso (FIG. 3.3). Fine strokes of vermilion red further model the cheeks, lips, tip of the nose, and eyes, while a very slight brown outlining provides the final articulation to the facial features, with painted gold for her eyebrows. On a smaller scale, Bourdichon did not always paint idealized female faces with such refinement. In one of his earliest works, the Katherine Hours, Bourdichon relied on a more formulaic facial treatment; using a three-part color method of white mixed with red for the pink flesh tone, he then modeled features with short parallel strokes of red, and down-modeled areas of shadow with longer parallel strokes of gray, as seen for instance in the face of the Virgin in *The Annunciation to the Virgin* (FIG. 3.17). In the Katherine Hours, Bourdichon's facial modeling may also have been indebted to Flemish manuscript painting technique, such as the work of Simon Marmion, as seen in *Saint Bernard's Vision of the Virgin and Child* (ca. 1475–80; FIG. 2.13), where Marmion built up the facial features with a loose network of fine strokes in red and brown over the base flesh tone.[17]

FIGURE 3.15
Detail from Plate 9

FIGURE 3.16
Detail from Plate 18

FIGURE 3.17
Jean Bourdichon, *The Annunciation to the Virgin* (detail; fig. 3.19). Katherine Hours, ca. 1480–85. JPGM, Ms. 6, fol. 27

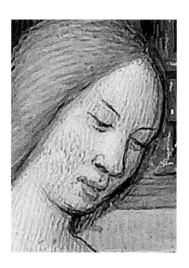

Painted gold highlights on draperies were one of Bourdichon's signature tech-niques, one he derived from Jean Fouquet. Fouquet's gold highlighting is remarkable for its delicacy and refinement on a small scale.[18] A convention that was used by earlier generations of illuminators, and by Fouquet's contempo-raries, gold highlights assumed a greater descriptive purpose in Fouquet's illu-minations. With areas of shadow within the drapery folds rendered using a dark blue glaze, Fouquet depicted areas of highlight from incident light upon a dark ground by varying the dilution, and hence the intensity, of the gold paint to suggest the distance from, or directness of, the light source. For instance, in the upper half of the Virgin's body from *The Virgin and Child Enthroned* in the Hours of Simon de Varie (FIG. 3.18), Fouquet described the profile of her bust and waist in a diluted gold paint, which was lightly applied to suggest a partial shadow, while he highlighted with a thicker, more robust application of undiluted gold paint on her proper right shoulder and arm, which are lit directly from above.

In Bourdichon's early Katherine Hours, drapery highlights were rendered in a way that was similar to Fouquet's technique. For instance, in *The Annun-ciation to the Virgin* (FIG. 3.19), layered parallel hatchings were used to model the folds in crosshatched gold with some stippling, suggesting Fouquet's tech-nical influence (FIG. 3.20). And like Fouquet, Bourdichon varies the dilution of gold paint, depending upon the intensity, distance, and angle and direction of the light source. Yet for all Fouquet's influence, Bourdichon is less spontaneous in his graphic approach to gold highlighting. Whereas Fouquet's stipples and strokes lent a greater feeling of depth and three-dimensionality to the folds, Bourdichon often relied upon a descriptive formula of long, parallel directional strokes that follow the contour of the drapery fold, with short cross-directional parallel strokes perpendicular to the fold line, to describe the ridge, which can give the drapery a more patterned, less volumetric appearance overall.

In the Hours of Louis XII, Bourdichon departed from Fouquet's tech-niques for rendering drapery, becoming considerably more linear in his ap-proach. Bourdichon rendered his draperies with a solid hue, modeled typically with a darker value of the same hue in the shadow areas and highlighted with painted gold in varying dilutions. For instance, in *The Presentation in the Temple* (PL. 13), Bourdichon employed long directional strokes in gold on the Virgin's blue robe (FIG. 3.21) and on Joseph's cowl, with no stippling, and very few cross-directional strokes.[19] Folds are more hard-edged than Fouquet's, often defined by long parallel clusters of thick to thin strokes of painted gold. Bour-dichon's brushwork can vary, from the very thickly applied gold on the man warming himself by the fire in *February* (PL. 2) to the extraordinary fineness of *The Virgin of the Annunciation* (PL. 9).

In *The Virgin of the Annunciation*, Bourdichon devoted exceptional care to the drapery, not unlike the care he clearly took in painting the Virgin's face. In her blue robe, Bourdichon's use of hatching and his skillful handling of the brush are exceptional. The entire garment is covered with series of parallel strokes in varying dilutions of gold to suggest a range of qualities of reflected

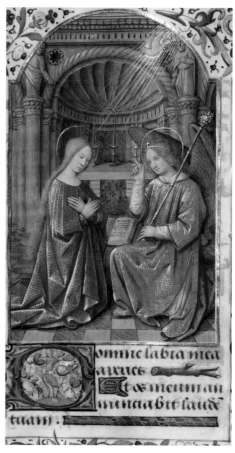

light (FIG. 3.22). Even more painstakingly, the Virgin's wimple is composed of a fine network of parallel white brushstrokes, suggesting the weave of a gauze-like fabric (FIG. 3.15).[20] Bourdichon's masterful and widespread use of parallel hatching, particularly in draperies, was a technique he clearly perfected—and evidence of his extraordinary control of the brush.

FOCUS AND SPATIAL RECESSION

To create spatial recession in his images, Bourdichon relied not only upon architectural surroundings, often composed on a system of one-point perspective, but also upon varying his use of details, such as sharpening focus on near objects while loosening brushwork to diffuse focus on distant objects, and using "scrims" of fine parallel lines of a lighter tone to mute certain features or colors to make objects recede in space.

Bourdichon would often display an almost obsessive interest in rendering meticulous details, particularly those in the foreground. For instance, he supplied the viewer with a nearly scientific description of the woven winnowing baskets in the foreground to *August* (PL. 4) and of the barrels in *September* (PL. 5). However, for figures, objects, and even distant landscapes, his focus broadened, and his painting technique loosened, as seen in the far background elements of *Bathsheba Bathing* (PL. 18) and *The Flight into Egypt* (PL. 14), where the skies and landscape contours were broadly laid in with horizontal bands of

FIGURE 3.18 (top left)
Jean Fouquet, *The Virgin and Child Enthroned* (detail; fig. 1.7). Hours of Simon de Varie, 1455. JPGM, Ms. 7, fol. 1v

FIGURE 3.19 (top right)
Jean Bourdichon, *The Annunciation to the Virgin* (detail). Katherine Hours, ca. 1480–85. JPGM, Ms. 6, fol. 27

FIGURE 3.20 (bottom left)
Jean Bourdichon, *The Annunciation to the Virgin* (detail; fig. 3.19). Katherine Hours, ca. 1480–85. JPGM, Ms. 6, fol. 27

FIGURE 3.21 (bottom right)
Detail from Plate 13

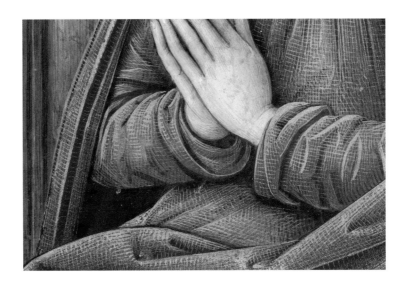

color and little detail. And while he frequently relied upon high-key, local color contrasts to make the foreground figures distinct, Bourdichon underpainted grouped background figures with a unified base tonality to enhance their spatial recession. For instance, in *The Presentation in the Temple*, the background figures were underpainted with brown to make them recede into space as a group, and colored details and gold highlights were added to differentiate the various figures (FIG. 3.23).[21] This device is used also in the background figures of *Pentecost* (PL. 15), where the brown undertone of the background becomes the base flesh tone of the faces, which are drawn in darker brown ink and red. Though this technique did not originate with Bourdichon, he did make effective use of it in areas of broad focus, such as in backgrounds.

As part of his approach to evoking spatial recession, Bourdichon also utilized a gauzelike overlay or a scrim of fine parallel strokes in order to mute or subdue elements within the composition. An isolated example of this technique can be found in the Katherine Hours, in the architectural niche in *The Annunciation to the Virgin* (FIG. 3.19), where Bourdichon painted parallel curved strokes in white over the clearly articulated recessed areas of the shell design to modify the shadows (FIG. 3.24). But by the date of the Hours of Louis XII, Bourdichon developed this technique much further. For instance, to depict the swaddling cloth in *The Presentation in the Temple*, Bourdichon painted the cloth first with a layer of lead white with blue-striped edging, and strokes of gray in the shadow (FIG. 3.25). He further diffused the blue edging pattern and the gray shadows by painting a fine network of parallel white horizontal lines over the swaddling cloth. This not only muted the intensity of the blue stripes and gray shadows but also added a white-on-white woven texture to the surface of the cloth. This technique is also employed in other passages, such as the tablecloth in *February* (PL. 2), across the surface of the book on the Virgin's lap in *The Virgin of the Annunciation* (PL. 9), and across the surface of Job's tattered white garment in *Job on the Dungheap* (PL. 19). This scrim technique may be original to Bourdichon, particularly to mute shadows in drapery folds or to modify specific details to enhance spatial recession.

LIGHTING EFFECTS AND LIGHT'S EFFECTS ON COLOR

Perhaps Fouquet's greatest influence on the young Bourdichon can be seen in the nocturnal scenes in the Katherine Hours (see FIGS. 3.27, 1.3). Taking his inspiration from Fouquet's nocturnal scenes, such as *The Arrest of Christ* (FIG. 3.26) or *The Nativity* (fol. 9) in the Hours of Etienne Chevalier,[22] Bourdichon made similar use of a muted palette of painted gold on brown and gray in the Katherine Hours. Yet he did not stop with gold reflections on the dark ground: for instance, in *The Annunciation to the Shepherds* (FIG. 3.27), one finds an early exploration into the effects of red-tinged reflected firelight on the shepherds' feet and legs (FIG. 3.28), an idea found later in his mature work.

As Janet Backhouse has pointed out, Bourdichon's "best work is distinguished by a characteristic luminous quality which results from a preoccupation with direct and usually visible sources of light."[23] By the date of the Hours of Louis XII, Bourdichon had taken much further his interests in contrasting light sources, their interplay, and the respective qualities of reflected light. In *The Nativity* (PL. 11) Bourdichon employed three light sources. The light of Joseph's lantern is a pale yellow-white pigment, which reflects a cool pale yellow off of Joseph's hat and clothing and the nearby timbers, while the holy light sources from above and from the radiant Christ child are rendered in painted gold and reflect painted gold highlights onto the roof of the stable and the Virgin's hands and face. Likewise, the scene from *February* (PL. 2) provides a similar exploration of reflected light: here the warm firelight is itself made to flicker with painted gold sparks and flames. This firelight, in turn, illuminates with a red glow the backside of the warmly clothed man, in contrast to the gold painted highlights on the front of his robe and arms lit by the window. Bourdichon extended this idea to dazzling effect in *The Annunciation to the Shepherds* (FIG. 3.29) in the Hours of Anne of Brittany, twenty years after the Katherine Hours. Using the shepherds' fire as the major light source, all the foreground figures are rendered in red reflected firelight, while the gold highlights from the radiant angel above reflect upon the shepherds' brown tunics and illuminate distant landscape details.

FIGURE 3.24
Jean Bourdichon, *The Annunciation to the Virgin* (detail; fig. 3.19). Katherine Hours, ca. 1480–85. JPGM, Ms. 6, fol. 27

FIGURE 3.25
Detail from Plate 13

OPPOSITE:
FIGURE 3.26 (top left)
Jean Fouquet, *The Arrest of Christ*. Hours of Etienne Chevalier, ca. 1452–61. Chantilly, Musée Condé, Ms. 71, fol. 14

FIGURE 3.27 (top right)
Jean Bourdichon, *The Annunciation to the Shepherds* (detail). Katherine Hours, ca. 1480–85. JPGM, Ms. 6, fol. 55

FIGURE 3.28 (bottom left)
Jean Bourdichon, *The Annunciation to the Shepherds* (detail). Katherine Hours, ca. 1480–85. JPGM, Ms. 6, fol. 55

FIGURE 3.29 (bottom right)
Jean Bourdichon, *The Annunciation to the Shepherds*. Hours of Anne of Brittany, ca. 1503–8. Paris, Bibliothèque nationale de France, Ms. lat. 9474, fol. 58v

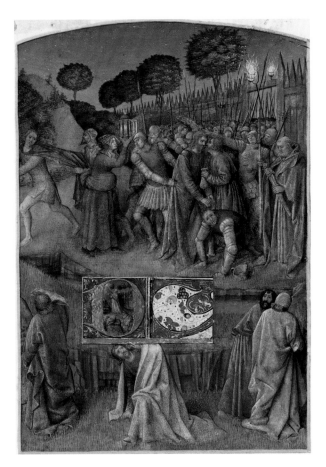

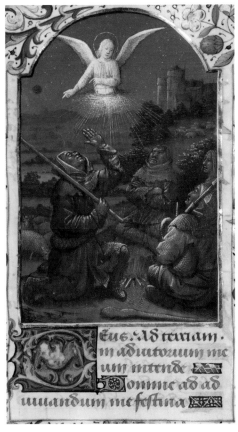

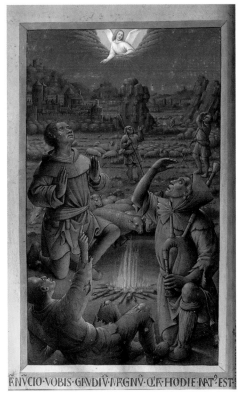

Equally innovative, yet much more subtle in its effect, is Bourdichon's approach to color and light in *The Flight into Egypt* from the Hours of Louis XII (PL. 14). Here Bourdichon conveyed the dusky light of the predawn sky by using muted highlights of gray pigment on the Virgin's blue robe. Compositional elements that are meant to be understood as white, such as the Virgin's wimple, the Christ child's swaddling, and Joseph's satchel hanging from his walking stick, are rendered in a gray tone of medium value. No pure whites were used. Bourdichon's use of gray lends a somber, quiet, and harmonic bridge between the cool-hued garments, namely the purple and blue of the Virgin's robes, and the warmer burgundy hue of Joseph's mantle and hat. Moreover, since the viewer of the image perceives the Holy Family in shadow, as the sun rises behind them, no gold highlighting is used on their features or their garments. Painted gold is reserved only to depict haloes and a few light-tinged background details in the distant landscape. Bourdichon's distinctive uses of color to depict lighting effects in these examples are notable for their sophistication and convey an understanding of color in nature and light's effects on color that challenges the widely assumed conservatism of his art.

CONCLUSION

Although an attempt has been made to contextualize the techniques found on a selection of the surviving leaves from the Hours of Louis XII, any conclusions drawn can only be understood as preliminary until a greater number of manuscripts can be studied in this way. Moreover, attributional questions separating Bourdichon's from secondary workshop hands cannot be answered as yet. What can be said from this limited study is that Bourdichon's remarkably skillful painting techniques appear fairly consistent between his early work in the Katherine Hours and the Hours of Louis XII. His debt to Jean Fouquet is clear, evident in the Katherine Hours, particularly in his method for rendering draperies and in his predilection for nocturnal scenes lit by gold painted highlights. In his early work, Bourdichon also appeared to derive some influence from Flemish illumination techniques, notably in the modeling of faces and his use of gold on gold.[24] In the Hours of Louis XII, there is a range in quality between the royal portrait or Annunciate Virgin and other facial types that, given the consistency in pigment palette between them, may be explained by a hierarchical approach, similar to what can be seen in Fouquet's treatment of faces in the Hours of Simon de Varie.

Among Bourdichon's characteristic working methods, his use of pigment mixtures in all his passages and his inclusion of the unusual bismuth black for warm grays are notable. His use of ultramarine and azurite in the flesh tones lends his figures a characteristically cool tonality overall, while effectively rendering shadow areas. He also exploited the warm and cool qualities in different pigments of a similar hue for their specific visual effects. Moreover, Bourdichon's slight departures from his initial drawings in the painted designs as seen by IRR, and his widespread use of pigment mixtures may suggest more invention within his working method than has previously been assumed.

Finally, in the Hours of Louis XII we can see how Bourdichon further

developed ideas that were only touched upon in the Katherine Hours. His use of "scrims"—a series of fine parallel lines employed to modify or soften shadows, to dampen the effect of a color, or to enhance spatial recession—may be one such innovation. His interests in the effects of light upon an object, contrasting light sources, and the moderation of color (depending upon the direction and intensity of the light source) to convey a more gradual, and hence naturalistic, effect of light were more highly developed in the Hours of Louis XII than in his earlier work. If these elements suggest the artist's direct observation of nature, perhaps Bourdichon was an artist who was more forward-looking in his approach to painting than has been previously understood. Whether he had contact with contemporary painters with similar interests or whether he was under the influence of artists' manuals that explored these issues are questions deserving further research.[25] Thus, for all the conservatism that has been generally associated with the manuscript illuminations of Jean Bourdichon, from a technical standpoint, we may now more fully understand why Bourdichon was one of the most successful illuminators of his time.

NOTES

1. Typical remarks such as this can be found in Anthony Blunt, *Art and Architecture in France: 1500–1700* (New York, 1973, reprinted 1998), p. 22; and David MacGibbon, *Jean Bourdichon: A Court Painter of the Fifteenth Century* (Glasgow, 1933), p. 90. The clearest reference to Bourdichon's technique vis-à-vis his style is given in L. M. J. Delaissé, James Marrow, and John de Wit, *Illuminated Manuscripts: The James A. de Rothschild Collection at Waddesdon Manor* (London, 1977), pp. 424, 434–45.

2. I would like to thank Thomas Kren for encouraging me to contribute to this volume. I am extremely grateful to Karen Trentelman, Senior Scientist and Head of the Museum Research Laboratory at the Getty Conservation Institute, for conducting the pigment studies, and to Yvonne Szafran in the Department of Paintings Conservation of the J. Paul Getty Museum for generously capturing infrared reflectograms from the three Getty leaves. For allowing me to study works by Bourdichon and his contemporaries, thanks also go to the following: Scot McKendrick of the British Library; Marie-Pierre Lafitte of the Bibliothèque nationale de France, Paris; William Lang of the Free Library of Philadelphia; Roger Wieck of the Pierpont Morgan Library, New York; and Sam Fogg on behalf of a private collector. Thanks also to Marika Spring for references to bismuth pigments.

3. As this investigation is only preliminary, neither pigment analysis nor infrared reflectography has been conducted on the Katherine Hours or the Hours of Simon de Varie.

4. Underdrawing can also be detected by the naked eye in areas of loss in other miniatures from the Hours of Louis XII, including *Pentecost* (pl. 15), the four surviving calendar miniatures (pls. 2–5), and in *Job on the Dungheap* (pl. 19).

5. An Inframetrics Infra-cam digital camera (with a sensitivity range between 1–2.5 microns) was used to detect the underdrawing.

6. See p. 67 and notes 11 and 12 below for a discussion of the materials used in the painting of the trees and their appearance in infrared.

7. Pigment analysis for this study was confined to the three Getty leaves. Analytical testing was not made on either the Katherine Hours or the Hours of Simon de Varie; thus, no direct correlations regarding pigments can be made to these earlier works at this time. X-ray fluorescence analysis was performed using a Jordan Valley EX3600-OA spectrometer. Raman analysis was performed using a Renishaw inVia Raman microscope. A detailed discussion of this work will be presented in a forthcoming publication.

8. Azurite was also identified in *Louis XII of France Kneeling in Prayer* (pl. 1) as a retouching pigment in the blue sky (at left and right edges) and in Louis XII's blue and silver leg armor.

9. Originally the visual effect would have been the inverse of what is visible today: areas of silver would have been lighter in value and highly reflective, and the areas of blue along the lengths of the king's arm and leg armor would have appeared as areas in shadow.

10. This pigment was first detected through XRF by the strong presence of bismuth. Under binocular magnification (500x), the particles appear dark silvery gray with a reddish reflective appearance. Bismuth black can occur in one of two forms: either as metallic bismuth or as bismuth trisulfide. Raman analysis indicated that metallic bismuth was used in the miniatures.

11. Bismuth ink recipes are given in fifteenth- and sixteenth-century recipe collections (Doris Oltrogge, personal communication). The only other published occurrence of metallic bismuth (with black and reflective areas) in a book is from colored engravings on paper from a fifteenth-century German Bible (Tiroler Landesmuseum, Innsbruck, Inventory no. F.B. 129), identified by Katharina Mayr in *Wismutmalerei*, diploma diss. (Meisterschule für Konservierung und Technologie an der Akademie der Bildenden Künste, Vienna [1977]), as cited in Renate Gold, "Reconstruction and Analysis of Bismuth Painting," in *Painted Wood: History and Conservation*, edited by Valerie Dorge and F. Carey Howlett (Los Angeles, 1998), p. 175 and footnote 10. I thank Marika Spring for this reference. Bismuth black has also been identified in sixteenth-century panel paintings: see Marika Spring, Rachel Grout, and Raymond White, "'Black Earths': A Study of Unusual Black and Dark Grey Pigments Used by Artists in the Sixteenth Century," *National Gallery Technical Bulletin* 24 (2003), particularly pp. 102–4 and note 60.

12. This behavior in the infrared was first characterized by Marika Spring. Cf. Spring, Grout, and White 2003, p. 105.

13. See Gold 1998, pp. 166–78.

14. See Janet Backhouse in Thomas Kren, ed., *Renaissance Painting in Manuscripts: Treasures from the British Library*, exh. cat. (Malibu, 1983), p. 167. See also her evidence for this practice in her discussion of Perréal, p. 173.

15. For references to Fouquet's manuscript painting technique, see Nicole Reynaud, *Jean Fouquet* (Paris, 1981), p. 50–51; see also James Marrow in *The Hours of Simon de Varie* (Los Angeles, 1994), pp. 68–69.

16. Otto Pächt, "Jean Fouquet: A Study of His Style," *Journal of the Warburg and Courtauld Institutes* 4, no. 1/2 (1940–41), p. 89.

17. Nancy Turner, "The Suggestive Brush: Painting Technique in Flemish Manuscripts from the Collections of the J. Paul Getty Museum and the Huntington Library," to be published in the forthcoming symposium proceedings volume relating to the exhibition *Illuminating the Renaissance: The Triumph of Flemish Manuscript Painting in Europe*.

18. For the most recent work and complete bibliography on the Hours of Simon de Varie, see François Avril, *Jean Fouquet: Peintre et enlumineur du XVe siècle*, exh. cat. (Paris, 2003), cat. no. 23, pp. 187–92. See also Reynaud 1981, p. 51, for remarks on Fouquet's use of gold.

19. It should be noted that the lower right corner of *The Presentation in the Temple* (pl. 13) has been repainted, in the blue drapery of the Virgin and in the red of the attending woman at the far right edge, including portions of the gold highlighting on both their draperies.

20. When inspecting his drapery passages closely, one has to wonder whether Bourdichon might have employed some kind of specialized brush that would lay down parallel, single-haired brushstrokes, the way a multipronged rake creates parallel scratches in the dirt. The existence of such a tool might help to explain the efficiency with which he or members of his workshop were able to produce so many manuscripts and retain such a unified appearance among them. In one example, a rakelike stroke can clearly be seen in a roughly contemporary book of hours by Bourdichon (London, British Library, Ms. Harley 2877), where the sleeve of the foreground apostle at left in the Pentecost (fol. 45v) was modeled with downward parallel strokes with daubs at the end of each stroke that seem to terminate simultaneously (visible with raking light under binocular magnification). Whether Bourdichon employed such a brush can only be speculated upon.

21. Fouquet appears to have used a similar technique for groups of background figures, as for example, in *The Martyrdom of Saint Apollonia* (fol. 46) from the Hours of Etienne Chevalier, to create the effect of a monochromatic background frieze of figures behind the more brightly colored active foreground participants in the scene. See Avril 2003, cat. no 24.46, p. 210. Generally, though, Fouquet tended to rely upon a highly constructed linear perspective in his compositions to force spatial recession within his images. See John White, *The Birth and Rebirth of Pictorial Space* (London: 1987), pp. 225–29; and Marie-Thérèse Gousset, "Fouquet et l'art de géométrie," in Avril 2003, pp. 82–86.

22. Avril 2003, p. 199, plates 24.7, 24.9.

23. Janet Backhouse, "Bourdichon's 'Hours of Henry VII,'" *British Museum Quarterly* 37 (Autumn 1973), p. 99.

24. In addition to Bourdichon's technique for rendering faces, or his use of gold on gold, consider also his indebtedness to Simon Marmion's illuminations in a book of hours known as "La Flora" (Naples, Biblioteca Nazionale, Ms. I B 51) for the dramatic close-up half-length compositions, as discussed by Janet Backhouse in this volume (see p. 15 and fig. 1.5).

25. Though Bourdichon may not have experienced Italian art firsthand, his explorations of color and the effect of light on color may hint at an interest in technical issues that occupied contemporary Italian painters as well as fifteenth- and early-sixteenth-century artists' manuals. For one such discussion of these manuals, see Moshe Barasch, *Light and Color in the Italian Renaissance Theory of Art* (New York, 1978).

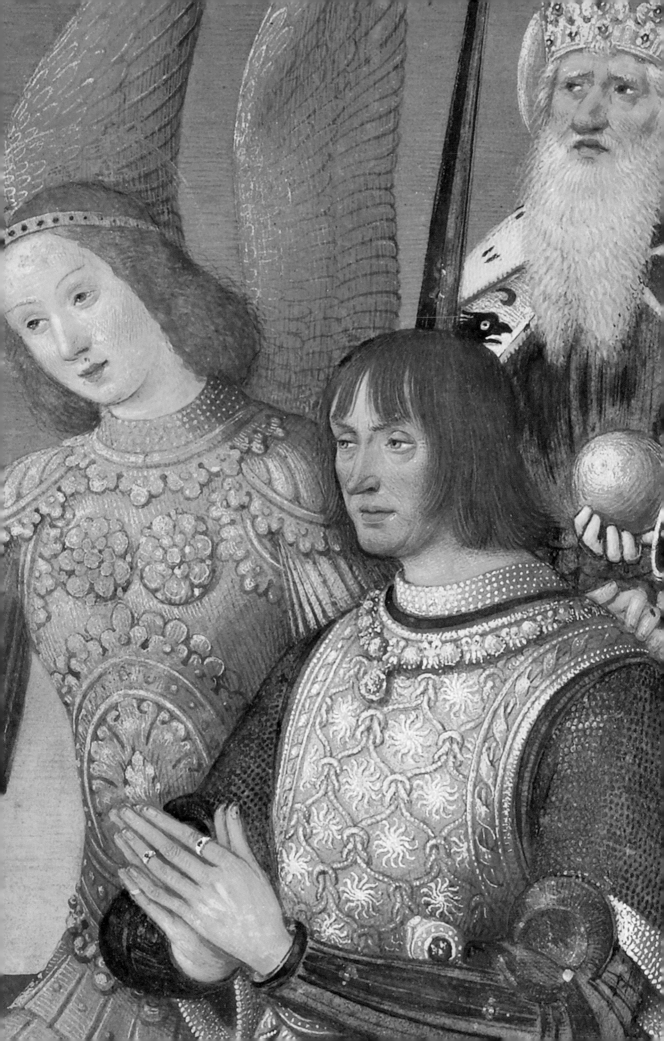

The Rediscovery of a Royal Manuscript

MARK EVANS

The Hours of Louis XII was broken up by 1700; most of its miniatures were dispersed, and its surviving text is fragmentary. This essay endeavors to trace the history of its constituent parts. The largest of these is a slender volume with fifty-one text leaves decorated with highly distinctive floral borders of stylized acanthus and naturalistic blossoms, which formed part of the English royal library, presented in its entirety to the then-recently established British Museum in 1757 by George II (1683–1760).[1] Until lately the book was known as the Hours of Henry VII. A tradition of earlier English royal ownership is referred to in the inscriptions "H. VII. R" and "HORAE/REGIS/HENRICI/VII" on the spine of its nineteenth-century binding. As this history was assumed by the Reverend Thomas Frognal Dibdin (1776–1847) in his *Bibliographical Decameron*, published in 1817, it has been plausibly inferred that the inscriptions were copied from an earlier binding.[2]

In an attempt to reconcile this traditional Tudor provenance with the material evidence of Louis XII's ownership, it has been suggested that the book was brought to England by Mary Tudor (1496–1533), the French king's third and last wife and the youngest daughter of Henry VII (1457–1509).[3] Louis and Mary married in October 1514, but he died on January 1, 1515. The following month, his widow secretly married Charles Brandon, 1st Duke of Suffolk (ca. 1484–1545), a favorite of Henry VIII (1491–1547), so perhaps she returned to England with her late husband's book of hours. We know that Mary brought at least one fine illuminated manuscript back from France: a book of hours decorated around 1500–1505 by Jean Poyet (act. ca. 1483–1503), one of Bourdichon's principal competitors, which she gave to her brother in 1530.[4] While it is difficult to imagine how Henry VII would have acquired the Hours of Louis XII, the brief marriage of Mary to Louis suggests a plausible path for its early arrival in England and its subsequent association with Henry, the founder of the Tudor dynasty.

Nevertheless, the first documentary evidence of the whereabouts of the book locates it in England around 1700. That year the famous diarist and naval administrator Samuel Pepys (1633–1703) put together the albums of calligraphy that remain in the library that bears his name, at Magdalene College,

Cambridge. The first volume of Pepys's calligraphic collection includes part of a leaf of text from the section of Louis' prayer book devoted to the Hours of the Holy Sacrament.[5] Another single text leaf, from its abbreviated paraphrase of the Psalms, was pasted into one of the numerous volumes of fragments assembled by John Bagford (1650–1716), which later passed with the Harleian Library to form part of the foundation collections of the British Museum in 1753.[6] Bagford was originally a shoemaker but became a dealer in "out of course books."[7] Like Pepys, he was an early collector of broadsides and printed ephemera and assembled innumerable ballads, title pages, and fragments of books, from which he planned to write a history of printing. Bagford seems to have acquired the rarities in his collection, such as his fragments of a Gutenberg Bible, from damaged volumes in the process of dispersal.[8] During the years before 1700, he seems to have had access to the Hours of Louis XII, although he only retained a single leaf from the manuscript.

As the volume of text leaves from this manuscript—later given to the British Museum—is not listed in the catalogue of the royal library published in 1734, it was probably acquired by George II after that date. This is consistent with its shelf mark, which shows that it was the final volume in a row of forty books. Its documented existence indicates that the miniatures had been extracted from the Hours by 1734–57. Dibdin's remarks on the text leaves, published in 1817, provide the earliest surviving appraisal of the manuscript:

> . . . among the Royal MSS. in the British Museum, (*Bibl. Reg.* 2 D. XL) there is a thin
> folio volume of *Hours*, of exceedingly delicate vellum, with a noble bottom and side
> margin, having a small text of only 18 lines—once the property of Henry VII—which
> exhibits vastly pretty side borders of fruit and flowers; worth the attention of any artist
> to copy, who is in pursuit of specimens of this nature. This book is imperfect at the
> beginning and end, and several leaves appear to be missing in other parts . . [9]

In 1849, lithographic reproductions of several of these text leaves (FIG. 4.1) were published in *The Illuminated Books of the Middle Ages*, by Henry Noel Humphreys and Owen Jones, where they immediately precede color reproductions from the closely related Hours of Anne of Brittany.[10] Humphreys implicitly associated the two volumes and dated the London leaves earlier, but he wrongly attributed their decorations to English rather than French illuminators.

What appears to be the earliest critical account of some of the full-page miniatures from the Hours of Louis XII was provided by the German art historian Gustav Waagen (1794–1868), the Director of the Altes Museum in Berlin and a principal early authority on Northern Renaissance painting. On September 1, 1835, he visited the Lansdown Tower in Bath, the later home of the legendary collector William Beckford (1760–1844) (FIG. 4.2), patron of the colossal short-lived Fonthill Abbey.[11] Despite being hurried through the rooms in the company of an English family who "did not feel it necessary to be so deliberate in their inspection as I heartily wished," Waagen nevertheless recognized, in the ground floor vestibule:

On two leaves of parchment, the Virgin and Child, with persons worshipping them. French miniatures, of the greatest delicacy, of about the same period as the prayer-book of Anne of Bretagne—that is, about 1500—and not inferior. Persons worshipping. Judging by the warm, brownish shadows, and character in other respects, by the greatest French miniature-painter, JEAN FOUQUET, painter to King Louis XI: at all events of his school.[12]

Beckford had been collecting illuminated manuscripts since 1784, principally late works of the fifteenth and sixteenth centuries.[13]

The documented history of Bourdichon's miniature of *Louis XII of France Kneeling in Prayer, Accompanied by Saints Michael, Charlemagne, Louis, and Denis* (PL. 1), acquired by the Getty Museum in 2003, indicates its ownership by Beckford. It is itemized in the sale catalogue of his *Valuable and Costly Effects* dated July 28, 1848: "A highly-finished Illuminated Drawing on Vellum, Loys XII, at his Devotions, attended by Sts. Michael, Charles, Loys and Denis."[14] This was purchased for eleven pounds and sixpence for the English politician Henry Laboucherre, later Lord Taunton (1798–1869), in whose collection it was seen once again by Waagen in 1850.[15] The miniature remained with Lord Taunton's heirlooms until its sale on July 14, 1920, when it was acquired by the French collector Baron Edmond de Rothschild (1845–1934).[16] Seized by the Nazis after the fall of France, it was later recovered and included in an exhibition of repatriated masterpieces from French collections, in Paris in 1946.[17]

It is highly plausible that *Louis XII of France Kneeling in Prayer* was paired with a facing miniature of *The Virgin and Child*—a configuration utilized by Bourdichon's master, Jean Fouquet, in the Hours of Simon de Varie

FIGURE 4.3
T. L. Atkinson (after
W. W. Ouless), *John Malcolm
of Poltalloch*, ca. 1860.
Mezzotint, 35.2 × 30.2 cm
(13 7/8 × 11 7/8 in.). London,
British Museum, 1931-5-8-2

(FIG. 1.7) and in Fouquet's masterpiece, the Hours of Etienne Chevalier.[18] Waagen's specific comparison of the miniatures he saw in Bath with the Hours of Anne of Brittany—of a similarly large scale—and his reference to their "warm, brownish shadows" strongly suggest that they were identical with *Louis XII of France Kneeling in Prayer* and a pendant of *The Virgin and Child*, whose whereabouts are since unknown. His description of these miniatures as on two leaves of parchment implies that they were framed separately. The latter may be identical to one of the two subsequent lots in Beckford's 1848 sale, each described only as "A Subject from Sacred History, highly illuminated, on vellum, in a costly frame, protected by Glass."[19]

I am grateful to François Avril for pointing out that Beckford also owned an early double-page frontispiece by Bourdichon; that of *Charles de Martigny, Bishop of Elne, Kneeling in Prayer before the Virgin and Child* (FIG. 1.9), which seems to have passed to Beckford's son-in-law, the 10th Duke of Hamilton (1767–1852), and was later acquired by Calouste Gulbenkian (1869–1955).[20] While it cannot be excluded that Waagen's comments of 1835 refer to this frontispiece, this seems unlikely, as it is less closely reminiscent of the Hours of Anne of Brittany and is much smaller (14.6 × 10.1 cm) than *Louis XII of France Kneeling in Prayer* (24.3 × 15.7 cm).

Probably sometime between June 24, 1891, and his death on May 30, 1893, the Argyll landowner John Malcolm of Poltalloch (1805–1893) (FIG. 4.3) acquired three miniatures from the Hours of Louis XII, which are listed in an apparently autograph addendum to his own copy of the catalogue of his collection:

Three miniatures with broad gold borders.

a. Job and his three friends

b. The Madonna

c. The Pentecost

from a Book of Hours.[21]

The finest of this trio depicts *The Virgin of the Annunciation* (PL. 9) and would originally have faced a miniature (now lost) of *The Archangel Gabriel*, at the beginning of the section of the manuscript dedicated to the Hours of the Virgin.[22] The others came from elsewhere in the book: *Pentecost* (PL. 15), opening its Short Hours of the Holy Spirit; and *Job on the Dungheap* (PL. 19), its Office of the Dead.[23] Malcolm's superb collection of over fourteen hundred old master drawings and prints was sold by his son to the British Museum in 1895—an event that moved the then Keeper of Prints and Drawings to observe that it "almost doubled the importance of the department I had the honor to serve."[24] Shortly before his death, Malcolm had given the Museum his finest illuminated manuscript, the Sforza Book of Hours.[25] A further twenty-one manuscript cuttings, including the three Bourdichon leaves, came with his drawings and were transferred on January 9, 1899, to the Department of Manuscripts, where they were initially catalogued as Flemish.[26]

A further four leaves from the Hours of Louis XII were offered for sale by the London bookseller James Tregaskis on February 12, 1917:

> ILLUMINATIONS: FOUR LEAVES FROM A BOOK OF HOURS. Written on vellum, and richly illuminated by a French Scribe and Artist; each of the four leaves measure $9^{3/8} \times 5^{1/2}$ ins., from the Kalendar: June, August, September and February; the Kalendar is written in blue and gold, and occupies in each case a space 6 by $3^{1/4}$ ins, while the rest of the page contains a large Miniature, very finely executed, representing:
>
> (a) A REAPER WITH SCYTHE, ETC., VIEW OF A TOWN IN THE DISTANCE;
>
> (b) A MILLER WINNOWING GRAIN;
>
> (c) MAN TREADING GRAPES IN A WINEPRESS;
>
> (d) NOBLEMAN STANDING BEFORE A TABLE, ON WHICH IS A REPAST.
>
> Each Miniature is surmounted by the Zodiacal signs, painted in blue and gold on a blue ground: Cancer, Virgo, Libra and Pisces respectively; the verso of each leaf contains the continuation of the Kalendar, with a wide single border of flowers, fruit and insects, painted in colours on a gold ground. Bound in brown polished levant morocco, gold line border on sides. £95 c. 1510.[27]

Tregaskis's enthusiasm for these calendar miniatures is apparent from his unusual procedure of including an illustration of *June* (PL. 3) inside the cover of the catalogue. The entire group, including, in addition to *June*, the leaves for *August* (PL. 4), *September* (PL. 5), and *February* (PL. 2), was purchased by the Philadelphia maritime lawyer, local historian, and collector John Frederick Lewis (1860–1932), whose widow gave his collection of over three hundred and fifty manuscripts and two thousand leaves and cuttings to the Free Library of Philadelphia in 1936.[28] The calendar leaves were identified as part of the Hours of Louis XII in 2001.[29]

Three more miniatures from the Hours of Louis XII came to light in England between the Second World War and the mid-1950s. *The Nativity* (PL. 11), from its Hours of the Virgin, is first recorded in the ownership of the surgeon and radiologist Dr. Christopher Kempster (1869–1948), who gave it in about

1940 to a friend he had met on a voyage to India in 1926. Brought briefly to the British Museum for examination in 1952, this miniature was thereafter unseen for fifty years and was purchased by the Victoria and Albert Museum in December 2003.[30] A miniature of *Saint Luke Writing* (PL. 7), from the Gospel extracts, was sold at Sotheby's on October 14, 1946, with an attribution to "School of Bruges 1500."[31] It was bought for £30 by the antiquarian book dealers Maggs Bros., who recognized its relationship to the Bourdichon miniatures in the British Museum and sold it in May 1947 to a regular customer, W. L. Wood, of London and Chandlers Cross.[32] Wood was of Scottish origin, and he gave the miniature with two other items to the National Library of Scotland in 1956.[33] In January 1955 the Bristol Art Gallery received *The Visitation* (PL. 10), also from the Hours of the Virgin, as a gift from their Friends association, which had purchased it for £150 from a Miss R. L. Williams. The miniature came with the visiting card of a man named Arthur Smith inscribed: "This beautiful & ancient picture was left as a legacy by Ann Alexander to her niece E. Hipsley." It was later attributed to Bourdichon by the distinguished scholar Otto Pächt.[34]

In the early 1970s, another three miniatures from the Hours of Louis XII emerged from British sources. D. E. Schwabach, of London, brought the miniature of *Bathsheba Bathing* (PL. 18), from the Penitential Psalms, to the British Museum for opinion in September 1971.[35] A year later, *The Flight into Egypt* (PL. 14), from the Hours of the Virgin, was similarly brought in by Sir Tom Hickinbotham (1903–1983), a former governor of Aden, who recalled that it had been acquired by his grandfather.[36] Both miniatures were identified by Janet Backhouse, who published them in her fundamental article on the Hours of Louis XII.[37] In 1974 they were sold at auction: *The Flight into Egypt* at Sotheby's on July 8, and *Bathsheba Bathing* at Christie's on July 11.[38] The latter was sold with a previously unknown miniature from the manuscript, *The Adoration of the Magi* (PL. 12), also from its Hours of the Virgin.[39] This had belonged to Mrs. Patricia Clogg, a daughter of the London antiquarian bookseller Lionel Robinson (1897–1983).[40] As Robinson and his younger brother Philip had purchased in 1946 the still-enormous residual contents of the library of Sir Thomas Phillipps (1792–1872), it is possible that *The Adoration of the Magi* came from this monumental collection of over sixty thousand manuscripts.[41] All three of these miniatures were purchased by the antiquarian book dealer Bernard H. Breslauer (1918–2004): *The Flight into Egypt* for £2,300, and *Bathsheba Bathing* and *The Adoration of the Magi* for £6,800 each. A few months earlier, in March 1974, Breslauer had bought from the New York book dealer H. P. Kraus yet another, also previously unidentified, miniature from the manuscript: *The Presentation in the Temple* (PL. 13), from its Hours of the Virgin.[42] Breslauer's collection was dispersed in 2003–04, and *Bathsheba Bathing* and *The Presentation in the Temple* were acquired by the Getty Museum, where they were reunited with *Louis XII of France Kneeling in Prayer*.[43] *The Adoration of the Magi* was sold to the Musée du Louvre, and *The Flight into Egypt* entered a British private collection.

The only miniature from the Hours of Louis XII identified since Bres-

lauer's purchasing campaign of 1974 also belonged to a well-known art dealer. This is *The Betrayal of Christ* (PL. 8), probably from its Passion According to St. John, one of over three hundred single manuscript leaves assembled by Georges Wildenstein (1892–1963) and given by his son Daniel in 1980 to the Musée Marmottan in Paris.[44] Its painted frame has been almost entirely cropped, leaving *The Betrayal of Christ* markedly smaller than the other identified miniatures from the Hours of Louis XII, and obscuring its relationship to them, which was not noticed until 1993.[45]

What may one deduce from the known history of the constituent parts of the Hours of Louis XII? It is unremarkable that the sources are silent during the later sixteenth and seventeenth centuries, when illuminated manuscripts were seldom appreciated as works of art. The separation of the miniatures from the text by 1700 is an unusually early instance of a practice that became common in the late eighteenth and early nineteenth centuries.[46] The comparatively unfaded condition of the miniatures suggests that they passed much of the three centuries since this dispersal within the protection of a binding. This is confirmed by the bound state in which the Philadelphia calendar leaves and the Edinburgh *Saint Luke Writing* first appeared.

The interest of Samuel Pepys and John Bagford in the Hours of Louis XII was confined to its textural content. William Beckford was less a medievalist than a refined eclectic, whose luxurious taste spanned a gamut of styles ranging from classical antiquity to those of his own day. It was fortuitous that his miniatures caught the eye of Gustav Waagen, one of a new breed of professional art historians. As a collector, Sir Thomas Phillipps—the antithesis of Beckford—was a self-confessed "vellomaniac" who assembled one of the largest manuscript collections in history, joking that he wished to have a copy of every book in the world. The large scale and pictorial character of Bourdichon's miniatures evidently commended them to John Malcolm, who generally concentrated on old master drawings and prints.

By the late nineteenth century, illuminated manuscript leaves were popular with middle-class collectors, including Ann Alexander and Sir Tom Hickinbotham's grandfather. Rich Americans had become major collectors of illuminated manuscripts by 1917, when John Frederick Lewis bought the calendar leaves. W. L. Wood's purchase of *Saint Luke Writing* suggests that he shared the taste, if not the means, of such wealthy manuscript collectors as C. W. Dyson Perrins (1864–1958) and Sir Alfred Chester Beatty (1875–1968). Dr. Christopher Kempster gave away *The Nativity* at a time when it was of modest financial value, while Hickinbotham and D. E. Schwabach sold *The Flight into Egypt* and *Bathsheba Bathing* for good prices in 1974. The professional dealers Georges Wildenstein and Bernard Breslauer assembled connoisseurs' collections of single miniatures when entire manuscripts of comparable quality were increasingly scarce and expensive.

In recent years, five additional miniatures from the Hours of Louis XII

have appeared, and two have emerged from decades in obscurity. More has been learned about the later history of its scattered elements, and all except one of its known leaves are now in public collections. Parts of what may be every section of the manuscript have been identified, giving a clearer idea of its original disposition. Its association with Louis XII has been confirmed, elucidating its character as a precursor of the better-known Hours of Anne of Brittany. While the total number of leaves discovered still amounts to a little less than half the original number, it is to be hoped that yet more missing leaves will come to light.

NOTES

1. London, British Library, Royal Ms. 2 D XL; see Janet Backhouse, "Bourdichon's 'Hours of Henry VII,'" *British Museum Quarterly* 37 (Autumn 1973), p. 97; George F. Warner and Julius P. Gilson, *Catalogue of Western Manuscripts in the Old Royal and King's Collections* (London, 1921), vol. 1, p. 62.

2. Thomas Frognal Dibdin, *The Bibliographical Decameron* (London, 1817), vol. 1, p. clix.

3. François Avril and Nicole Reynaud, *Les Manuscrits à peintures en France, 1440–1520*, exh. cat. (Paris, 1993), pp. 295–96. For Mary's biography, see Walter C. Richardson, *Mary Tudor, The White Queen* (London, 1970).

4. Lyons, Bibliothèque Municipale, Ms. 1558; Avril and Reynaud 1993, pp. 314–5. A larger and more spectacular prayer book also decorated by Poyet is traditionally known as the Hours of Henry VIII (New York, Pierpont Morgan Library, Ms. H.8); Roger S. Wieck, William M. Voelkle, and K. Michelle Hearne, *The Hours of Henry VIII: A Renaissance Masterpiece by Jean Poyet* (New York, 2001), pp. 183–85. Its book clasps, with the arms of Henry VIII, appear to be of seventeenth-century Flemish design (I am grateful to Sophie Lee for this information). The provenance of this volume is anecdotal prior to its discovery at Mons in 1723. It also came into the hands of George II, who presented it in 1740 to the electoral library in Hanover.

5. Backhouse 1973, pp. 95–97.

6. Ibid.

7. W. Y. Fletcher, "John Bagford and His Collections," *Transactions of the Bibliographical Society*, vol. 4, July 1898, pp. 185–201.

8. Ibid., p. 195.

9. Dibdin 1817, vol. 1, p. clix.

10. Henry Noel Humphreys and Owen Jones, *The Illuminated Books of the Middle Ages* (London, 1849, reprinted 1989), pp. 108–13. See also Backhouse 1973, p. 101, and Sandra Hindman and Nina Rowe, eds., *Manuscript Illumination in the Modern Age: Recovery and Reconstruction*, exh. cat. (Evanston, 2001), pp. 165–69, 192–93.

11. Derek E. Ostergard, ed., *William Beckford, 1760–1844: An Eye for the Magnificent*, exh. cat. (Bard Graduate Center, New Haven and London, 2001).

12. Gustav Friedrich Waagen, *Works of Art and Artists in England* (London, 1838), vol. 3, pp. 114–16.

13. A. N. L. Munby, *Connoisseurs and Medieval Miniatures, 1750–1850* (Oxford, 1972), pp. 77–78.

14. Messers. English and Son, *Catalogue of the Valuable and Costly Effects at 20, Lansdown Crescent, Bath. The Property of the Late William Beckford, Esq.* (Bath, July 28, 1848, lot 30), bought by W. Graves (priced copy in the National Art Library, Victoria and Albert Museum).

15. Gustav Friedrich Waagen, *Treasures of Art in Great Britain* (London, 1854), vol. 2, p. 422: "Of the FRENCH SCHOOL I observed some masterly portraits of royal personages, among them Louis

XII, of the school of JEAN FOUQUET..."

16. Sotheby, Wilkinson, and Hodge, *Catalogue of Valuable Drawings and Oil Paintings, Forming Part of the Collection at Quantock Lodge, Bridgewater, The Property of E.A.V. Stanley, Esq.* (London, July 14, 1920, lot 67); David MacGibbon, *Jean Bourdichon: A Court Painter of the Fifteenth Century* (Glasgow, 1933), p. 104. (I am grateful to Christopher de Hamel for the latter reference.)

17. Albert S. Henraux, *Les Chefs-d'oeuvre des collections françaises retrouvés en Allemagne*, exh. cat. (Paris, 1946), p. 40, no. 105. (I am grateful to Peter Kidd for this reference.)

18. Los Angeles, J. Paul Getty Museum, Ms. 7, and Chantilly, Musée Condé, Ms. 71; François Avril, *Jean Fouquet: Peintre et enlumineur du XVe siècle*, exh. cat. (Paris, 2003), pp. 190, 196–97.

19. English and Son 1848, lots 36–37, sold for £3 – 6s – od and £1 – 10s – od respectively, to W. English, the auctioneer (priced copy of sale catalogue in the National Art Library, Victoria and Albert Museum).

20. Personal communication, September 9, 2004. Lisbon, Calouste Gulbenkian Museum, Ms. M 2, A, B, C; Avril 2003, pp. 190, 192; and idem, "Un nouveau manuscrit de Jean Bourdichon: Les heures de Charles de Martigny, évêque d'Elne" (forthcoming). The leaves appear to have passed to Hamilton's great-granddaughter, Lady Mary Louise Douglas Hamilton, Marchioness of Graham and later Duchess of Montrose (1884–1957). They were described as from the collection of the Marchioness of Graham in 1926; Sotheby and Co., *Catalogue of the Collections Formed by the Late Lord Carmichael of Skirling* (London, June 8, 1926, lot 485).

21. John Charles Robinson, *Descriptive Catalogue of Drawings by the Old Masters, Forming the Collection of John Malcolm of Poltalloch*, 2nd ed. (London, 1876), interleaved page, facing p. 280 (annotated copy in the British Museum, Department of Prints and Drawings). This has thirty further brief entries for works acquired since 1876, numbered in order of acquisition "Add. 1–30." The last datable entries for miniatures are for acquisitions from the Von Klinkosch sale at Vienna on April 15, 1889, and the final dated entry is for a Raphael drawing bought on June 24, 1891. The Bourdichon miniatures were not numbered (but later received the incorrect number 27, written in another hand). This suggests that they were acquired after April 15, 1889, and in all probability after June 24, 1891. (I am grateful to Stephen Coppel for assistance.) Robinson initially played a major role in Malcolm's collecting, but there is no mention of the Bourdichon leaves in Robinson's account book for the period 1874–1907 (Oxford, Ashmolean Museum, Department of Western Art).

22. British Library, Ms. Add. 35254, fol. V.

23. British Library, Ms. Add. 35254, fols. U, T.

24. Quoted in Martin Royalton-Kisch, Hugo Chapman, and Stephen Coppel, *Old Master Drawings from the Malcolm Collection*, exh. cat. (London, 1996), p. 17.

25. Mark Evans, *The Sforza Hours* (British Library, London, 1992).

26. British Library, Ms. Add. 35254, fols. A–V; Backhouse 1973, pp. 95–96; idem, "Hours of Henry VII" in Thomas Kren, ed., *Renaissance Painting in Manuscripts: Treasures from the British Library*, exh. cat. (Malibu, 1983), pp. 163–68.

27. James Tregaskis, 66 Great Russell Street, London W.C., *The Caxton Head Catalogue*, No. 789 (February 12, 1917, no. 312). (I am grateful to Martin Kauffmann for assistance with this reference.)

28. Seymour De Ricci, *Census of Medieval and Renaissance Manuscripts in the United States and Canada*, vol. 2 (New York, 1937), p. 2066, no. 250; James R. Tanis, ed., *Leaves of Gold: Manuscript Illumination from Philadelphia Collections*, exh. cat. (Philadelphia, 2001), pp. 70–74.

29. Roger Wieck, in Tanis 2001, pp. 70–74.

30. Purchased with the support of the National Heritage Memorial Fund, the National Art Collections Fund, and the Friends of the V&A; *Export of Works of Art 2002–2003*, Department for Culture, Media and Sport (London, 2003), pp. 69–71; Mark Evans, entry in *National Art Collections Fund 2003 Review* (London, 2004), p. 135.

31. Sotheby and Co., *Catalogue of Valuable Printed Books, Autograph Letters and Historical Documents, Etc.* (October 14, 1946, lot 148).

32. British Library, Department of Manuscripts, Maggs Archive, *Maggs 1593*, folders 1936–1947, file of W. L. Wood. (I am grateful to Kenneth Dunn and Rachel Stockdale for assistance.)

33. National Library of Scotland, Ms. 8999.

34. Information on inventory card. (I am grateful to Sheena Stoddard for assistance.)

35. Backhouse 1973, pp. 95, 101.

36. Ibid. Hickinbotham mentioned the earlier ownership of his miniature in conversation with Janet Backhouse in 1972.

37. Backhouse 1973, pp. 95–102.

38. Sotheby and Co., *Catalogue of Western Manuscripts and Miniatures* (July 8, 1974, lot 25); Christie, Manson, and Woods, *Important Western Manuscripts and Miniatures* (July 11, 1974, lot 7).

39. Christie, Manson, and Woods (July 11, 1974, lot 6).

40. Annotated photograph of *The Adoration of the Magi*, which was in the possession of the late Janet Backhouse.

41. The Robinson brothers purchased the rump of Phillipps's library, 90 percent of which was still unlisted, for £100,000. After three major sales at Sotheby's on July 1 and November 11 and 25, 1946, they gradually dispersed the collection until their retirement in 1956, and thereafter continued to sort it. Parts entered their own libraries, which were sold at Sotheby's on June 26–27, 1986, and June 23 and November 22, 1988. In 1977 they sold its remnants to the New York dealer H. P. Kraus. See A. N. L. Munby, *The Dispersal of the Phillipps Library* (Cambridge, 1960), pp. 94–112, and Alan Bell, entry on Sir Thomas Phillipps in *The Oxford Dictionary of National Biography* (Oxford, 2004).

42. William Voelkle and Roger Wieck, *The Bernard H. Breslauer Collection of Manuscript Illuminations*, exh. cat. (New York, 1992), pp. 76–81.

43. Los Angeles, J. Paul Getty Museum, Ms. 79, 79b.

44. Manuel Jover, *Les Enluminures de la Collection Wildenstein, Musée Marmottan* (Paris, 2001), p. 24.

45. Avril and Reynaud 1993, p. 294.

46. Hindman and Rowe 2001, p. 69.

Appendix: A Reconstruction of the Hours of Louis XII

THOMAS KREN *and* PETER KIDD

The following reconstruction is based on the observations of Janet Backhouse from her landmark article of 1973 on the Hours of Louis XII, supplemented by additional research. The shelf mark Royal Ms. 2 D XL cited below refers to the manuscript in the British Library, London.

SECTION OF BOOK	SURVIVING	LACKING
Frontispiece diptych	*Louis XII of France Kneeling in Prayer* (PL. 1), recto	Facing miniature: *The Virgin and Child* or *The Pietà* (?), verso
Calendar	*February* with calendar (PL. 2); *June* with calendar (PL. 3); *August* with calendar (PL. 4); *September* with calendar (PLS. 5–6)	*January, March, April, May, July, October, November,* and *December*: calendars and associated illuminations
Gospel Extracts	Two collects for use after the passage from Saint John (Royal Ms. 2 D XL, fol. 52); *Saint Luke Writing* (PL. 7), recto; with opening text from the Gospel According to Saint Luke, verso	Miniatures of *Saint John, Saint Matthew,* and *Saint Mark* along with associated Gospel extracts, and conclusion of the extract from the Gospel According to Saint Luke
The Passion According to Saint John	*The Betrayal of Christ* (PL. 8), reverse unexamined; John 18:11–23 (Royal Ms. 2 D XL, fol. 2); John 19:7–19 (Royal Ms. 2 D XL, fol. 3); John 19:30–41 (Royal Ms. 2 D XL, fol. 4)	Portions of the Passion According to Saint John: John 18:24; 19:6, 20–29, 42
Matins of the Hours of the Virgin	*The Virgin of the Annunciation* (PL. 9), recto; with opening text, verso	Facing miniature of *The Archangel Gabriel*; remaining text of Matins of the Hours of the Virgin

91

Lauds of the Hours of the Virgin	*The Visitation* (PL. 10), recto; with opening text, verso	Remaining text of Lauds of the Hours of the Virgin
Prime of the Hours of the Virgin	*The Nativity* (PL. 11), recto; with opening text, verso	Remaining text of Prime of the Hours of the Virgin
Terce of the Hours of the Virgin		*The Annunciation to the Shepherds*; Terce of the Hours of the Virgin
Sext of the Hours of the Virgin	*The Adoration of the Magi* (PL. 12), recto; with opening text, verso	Remaining text of Sext of the Hours of the Virgin
None of the Hours of the Virgin	*The Presentation in the Temple* (PL. 13), recto; with opening text, verso	Remaining text of None of the Hours of the Virgin
Vespers of the Hours of the Virgin	*The Flight into Egypt* (PL. 14), recto; with opening text, verso; a collect to be said after Vespers (Royal Ms. 2 D XL, fol. 41)	Remaining text of Vespers of the Hours of the Virgin
Compline of the Hours of the Virgin		*Coronation of the Virgin* or *Assumption of the Virgin* (?); Compline of the Hours of the Virgin
Short Hours of the Cross	The end of Lauds and most of Prime (Royal Ms. 2 D XL, fol. 44)	*Christ Carrying the Cross* or *The Crucifixion*; remaining text of the Short Hours of the Cross
Short Hours of the Holy Spirit	*Pentecost* (PL. 15), recto; with opening text, verso	Remaining text of the Short Hours of the Holy Spirit
Hours of the Conception of the Virgin	The end of Sext, all of None, Vespers, and Compline (PLS. 16–17; Royal Ms. 2 D XL, fols. 38 + 37, 43)	*Joachim and Anna at the Golden Gate* (?) (full-page miniature?); remainder of the Hours of the Conception of the Virgin

SECTION OF BOOK	SURVIVING	LACKING
Hours of All Saints	The end of None, all of Vespers, and Compline (Royal Ms. 2 D XL, fol. 42)	*All Saints* (?) (full-page miniature?); remainder of the Hours of All Saints
Hours of the Holy Sacrament	Part of a leaf of text (Cambridge, Magdalene College, Pepys's Calligraphical Collection, vol. 1, p. 13)	Full-page miniature (?); remainder of the Hours of the Holy Sacrament
Penitential Psalms	*Bathsheba Bathing* (PL. 18), recto; with opening text, verso; and next seven text leaves: Psalms 6, 31, 37, 50, and 101:1–26 (Royal Ms. 2 D XL, fols. 6–12)	Remaining text of Penitential Psalms: Psalms 101:26–29, 129, and 142
Litany	End of the confessors (with Martin and Gatian of Tours), all of the Virgins, and start of the petitions (Royal Ms. 2 D XL, fol. 13)	Opening of the Litany; end of the petitions, collects
Office of the Dead	*Job on the Dungheap* (PL. 19), recto; with opening text, verso; twenty disjointed text leaves (Royal Ms. 2 D XL, fols. 32, 22, 31, 23 + 5, 25 + 30, 26, 35, 14 + 15, 34, 36, 16 + 20, 39 + 33, 40 + 21 + 17)	Remaining text of the Office of the Dead

SECTION OF BOOK	SURVIVING	LACKING
Suffrages for Major Liturgical Feasts and Saints' Days	End of Good Friday, Holy Saturday, Easter Sunday, Saint George (April 23; Royal Ms. 2 D XL, fol. 49); end of Saints Philip and James (May 1), the Invention of the Cross (May 3), the Ascension (fol. 47); Pentecost, Trinity, Corpus Christi (fol. 45); Saint Barnabas the Apostle (June 11), the Birth of Saint John the Baptist (June 24; fol. 46); Saints Peter and Paul (June 29), Saint Martial (July 7), Saint Mary Magdalene (July 22; fol. 48v); end of the Death of Saint John the Baptist (Aug 29); Nativity of the Virgin (Sept 8), Exaltation of the Cross (Sept. 14; fol. 50v)	Full-page miniature (?) plus remainder of suffrages of the Virgin, Apostles, and other major church feasts
Paraphrase of the Psalms	Six leaves of abbreviated and paraphrased psalms somewhat similar to the Psalter of Saint Jerome (British Library, Harley Ms 5966, fol. 9 and Royal Ms. 2 D XL, fols. 18, 27 + 28 + 29, 19); end of a prayer and two collects (Royal Ms. 2 D XL, fol. 51)	Full-page miniature (?); remaining psalms
Further Psalms	One leaf with portions of psalms 2 and 5 (Royal Ms. 2 D XL, fol. 24)	

SUGGESTIONS FOR FURTHER READING

On the period

Baumgartner, Frederic. *Louis XII* (Scranton, Pa., 1994).

Camille, Michael. *The Medieval Art of Love: Objects and Subjects of Desire* (New York, 1998).

Huizinga, Johan. *The Autumn of the Middle Ages*, trans. by Rodney J. Payton and Ulrich Mammitzsch (Chicago, 1996).

On illuminated manuscripts

Avril, François. *Jean Fouquet: Peintre et enlumineur du XVe siècle* (Paris, 2003).

Avril, François, and Nicole Reynaud, *Les Manuscrits à peintures en France, 1440–1520* (Paris, 1993).

Backhouse, Janet. *Illuminations from Books of Hours* (London, 2005).

Faÿ-Sallois, Fanny. *A Treasury of Hours: Selections from Illuminated Prayer Books* (Los Angeles, 2005).

De Hamel, Christopher. *A History of Illuminated Manuscripts*, 2nd ed. (London, 1994).

Kren, Thomas, et al., *Masterpieces of the J. Paul Getty Museum* (Los Angeles, 1997).

Plummer, John. *The Last Flowering: French Painting in Manuscripts, 1420–1530* (New York, 1982).

Wieck, Roger S. *Painted Prayers: The Book of Hours in Medieval and Renaissance Art* (New York, 1997).

On individual French manuscripts by Jean Fouquet, Jean Bourdichon, and their contemporaries

Marrow, James. *The Hours of Simon de Varie* (Los Angeles, 1994).

Rosenthal, Jane E. *The Vatican Hours from the Circle of Jean Bourdichon* (Yorktown Heights, N.Y., 1989).

Wieck, Roger S., and K. Michelle Hearne, *The Prayer Book of Anne de Bretagne: MS M. 50, The Pierpont Morgan Library, New York* (Lucerne, 1999).

Wieck, Roger S., William M. Voelkle, and K. Michelle Hearne, *The Hours of Henry VIII: A Renaissance Masterpiece by Jean Poyet* (New York, 2001).

Index

Page numbers in *italics* refer to illustrations. Comparative works of art are listed under the respective artist (if known) and/or book in which the work appears.